# SALTAIRE
## THROUGH TIME

Gary Firth *&*
Malcolm Hitt

AMBERLEY PUBLISHING

Portrait and autograph of Sir Titus Salt *c.* 1876.

*Front cover:* Original bandstand in Titus Salt's public park *c.* 1910.
Below, the new bandstand on the park promenade in 2010.

First published 2010

Amberley Publishing Plc
Cirencester Road, Chalford,
Stroud, Gloucestershire, GL6 8PE

www.amberley-books.com

Copyright © Gary Firth & Malcolm Hitt, 2010

The right of Gary Firth & Malcolm Hitt to be
identified as the Authors of this work has been
asserted in accordance with the Copyrights, Designs
and Patents Act 1988.

ISBN 978 1 84868 741 7

British Library Cataloguing in Publication Data.

A catalogue record for this book is available from
the British Library.

Typeset in 9.5pt on 12pt Celeste.
Typesetting by Amberley Publishing.
Printed in the UK.

# Introduction

Saltaire and its mill have recently been elevated to World Heritage status alongside the Acropolis and the Taj Mahal. In this book we compare the village which Salt left behind in 1876 with the tourist attraction that Saltaire has recently become. Here, we dwell briefly on his lifetime achievements, already covered by a host of biographers, historians and social commentators who have told and retold the romantic story of Salt's rise from humble Yorkshire origins to his inclusion into the pantheon of successful millowners and businessmen of the nineteenth century Industrial Revolution. The best of these are Jack Reynolds' definitive *The Great Paternalist* (1983) and my own *Salt & Saltaire* (2001) both should help the reader fill any gaps about the man and his times.

Salt (1803-76) was made a baronet in 1869 having made his name as a Bradford manufacturer of fine quality worsted cloth, specialising in new raw materials like alpaca and mohair. In 1848 Salt looked to leave his Bradford mills and centralise his production on one enormous site, combining all the processes of manufacture. From the outset, Salt envisaged this huge manufactory as the centre piece of a model settlement of worker's housing and public buildings. As Jack Reynolds argued "the mill and model village were to bring together old and new, to unite the paternalism of an earlier age to the technology and economic structure of a new industrial society"

Let us suppose that Salt's ghost could return to the village today (March 2010) and look through the "current" photographs in this book. No doubt that he would know exactly where he was, as little of any significance has changed. Only the washhouse (1936) and his Sunday School (1972) have completely left the townscape which he created. The new Wesleyan Chapel might disappoint him in its modest dimensions, as might the footbridge which replaced the solid cast iron structure he built to cross the river. Only Albert Terrace retains the setts and cobbles of his original highways and side streets. He would be surprised at the replacement of horse traffic by cars and buses, and pleased by the replacement of street gas lamps by electricity. Most of his corner shops have been converted into houses and he would be shocked by the kinds of retailing in Victoria Road and in the mill. However, as a captain of industry I am sure he would applaud the microelectronic manufacture there by PACE.

Long before his death in 1876 Salt had encouraged his three sons to take an active part in the running of the mill and in village affairs. It was however entirely his decision alone, in 1868, to build New Mill overlooking the river to accommodate extra spinning capacity so great was the demand for his cloth throughout the 1860s. Following his death and a dramatic change of fickle fashion away from lustre cloth in ladies dresswear (to a more lightweight cloth) there occurred a downturn in the firm's output in the 1870s. This, and the effects of increasing competition and a world wide move towards protectionism (particularly from the USA in 1890) then led to reduced output at the mill and to the enforced formation of a joint-stock company and eventually to the sale of the mill by the Salt family in 1892. This had also come about as a result of the premature death of the managing director Titus Salt jnr aged forty-four, which brought about an abrupt end to the founder's dream of establishing a long lasting business dynasty. The winding up of the old company sent shockwaves through the Bradford trade and villagers feared for their future security.

Eventually both mill and village were sold to a business consortium of local millowners from which James Roberts was to emerge as the new owner in 1896. Under his management, the mill was modernised and extended enabling Saltaire to return to full employment and go back into profit by 1895. A year later Roberts became the sole owner of the mill and landlord to all of his 4,500 workforce. Following in the footsteps of the original founder he also purchased Milner Field from Mrs Titus Salt jnr. and erected a statue to Sir Titus in Saltaire Park (1903). The onset of war in 1914 took the mill into wartime production. With a rapidly dwindling workforce following the introduction of conscription, Roberts had great difficulty in keeping the business going particularly as he had the misfortune to outlive four of his five sons. By 1917 Roberts was finding his difficulties at the mill too onerous, forcing him into retirement and the sale of his interest in both mill and

village to another syndicate of Bradford wool men led by Sir James Hill. During the immediate post war period the business traded with a nominal capital of £1.5 million. By July 1923 Hill had restructructured the firm as a public company (value £4m), which went by the name of Salt's Saltaire Ltd. Through the 1920s it continued to manufacture mohair upholstery for the expanding motor industry and alpaca cloth for sportswear.

The board of directors continued Salt's precedent of public welfare by purchasing land between the river and the canal (towards Bingley) for playing fields for a variety of sports. The General Strike caused a brief temporary loss of trade although the financial crash of 1929 and the subsequent depression compelled the directors in 1933 to sell the village housing to a private company. After the 1939/45 war, the business became part of the Illingworth, Morris group (1958) and as late as 1976 the mill was producing £4m worth of cloth of which over half was for export. Thereafter, the story is a sad one, as the firm, after 1980, struggled to prosper in the general crisis affecting the entire British textile industry.

By 1985 the New Mill at Saltaire was totally derelict, the haunt of vagrants and vandals. When cloth production finally ceased at the main mill building in 1986 the owners simply closed it and put it up for sale. At the time it seemed as if Salt's cathedral of industry would meet a similar fate as the nearby New Mill. The prospect of an entire industrial complex falling into sad neglect and disuse appalled workers, planners, politicians and academics alike.

Conservation was in the air! Following a seminar in April 1986, ("Crisis at Saltaire") and subsequent to English Heritage listing the whole of Saltaire as a Grade Two site, Mr Jonathan Silver a self-made Yorkshire millionaire finally bought the mill site in 1987. What had become a symptom of decline was transformed by Silver into a beacon of regeneration and renewal. Thinking outside the box, Jonathan Silver was able to interface art, music, dining, retailing and high technology into a commercial and cultural amalgam befitting the third millennium. The founder of Saltaire would have easily identified with Silver's enterprise and the commercial and cultural mindset which motivated him prior to his untimely death in September 1998, aged only forty-seven. Thankfully his wife Maggie has continued his wonderful life's work.

The past and present photographs of Saltaire in this book are due largely to the dynamism and entrepreneurial vision shared by both Salt and Silver in this beautiful and ordered model village. One found it, the other has helped to preserve it. In the scientist's list of chemical elements it is perhaps no surprise to find that silver and salt (sodium) sit comfortably alongside each other as they do here at Saltaire.

G. Firth
March 2010

# Acknowledgements

Our greatest thanks are to the inhabitants of Saltaire of the past century, too numerous to acknowledge individually but their photographs and postcards have been carefully collated by the recently deceased Clive Woods of the Saltaire Village Society. We owe a particular debt of gratitude to Julie Woodward for access to the picture archives of the Shipley College Library. Others who have loaned images of the village and its life include Dorothy Firth, Stanley Varo, Ian Ward, Ian Beesley, Bert Thornton, Robert Pemberton, and Percy Price. If any copyrights have been infringed, there has been no deliberate intent and for anyone whose help has not been acknowledged the fault is entirely that of the authors, as are any factual errors in the text.

Gary Firth and Malcolm Hitt
August 2010

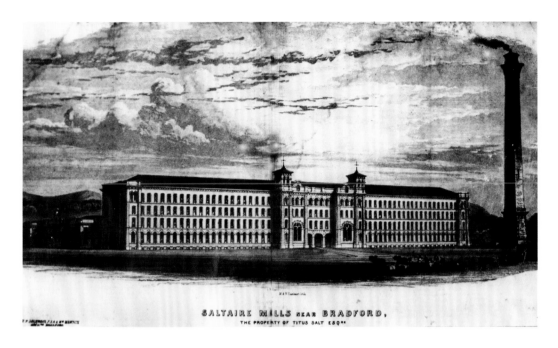

## Saltaire Mills 1853

This print of the façade of Saltaire Mill was contemporaneous with the mill's opening in 1853. It was Titus Salt's decision to place all the processes of worsted cloth production within a single manufactory, gradually closing his Bradford mills widely dispersed across the town. Designed by the Bradford architects Lockwood & Mawson, the mill was originally costed at £40,000 but it eventually cost Salt nearer £100,000. This imposing south front is made up of six storeys, the top floor of which runs undivided (by internal walls) the whole length of the mill (550 ft). The same view taken in 2009 from the bottom of Exhibition Road, overlooking the railway line. The Italianate appearance of the south front is partially lost by tree cover but the twinned lantern towers of Tuscan design can still be seen as book-ends to William Fairburn's engine house.

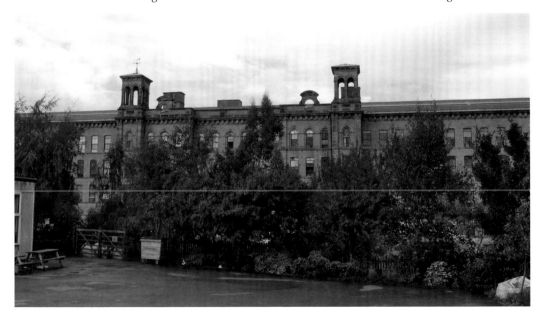

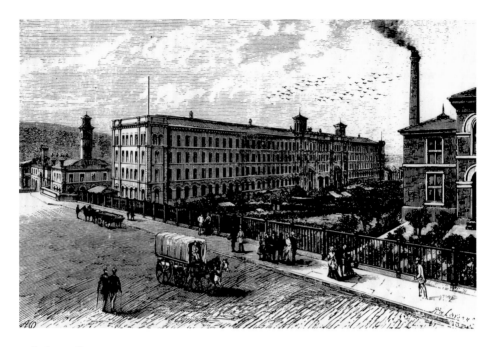

**Saltaire Mills 1884**

By the time of this engraving the New Mill (left) had been added in 1868 to the north side of the original factory in order to accommodate extra spinning capacity. On the extreme right is the front of the Congregational Sunday school (1876), the last of Salt's public buildings. The mill no longer makes worsted cloth but has become a major tourist attraction in the North of England. The Sunday school has gone to make way for public car parking/toilets. The Venetian campanile of the New Mill still stands but does not serve its former purpose as a mill chimney.

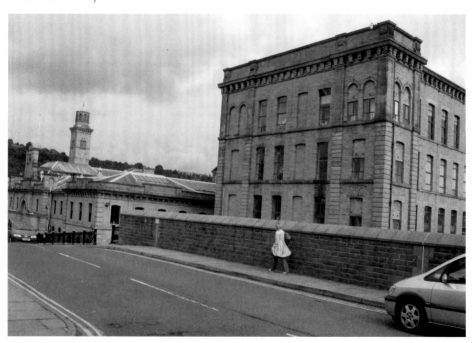

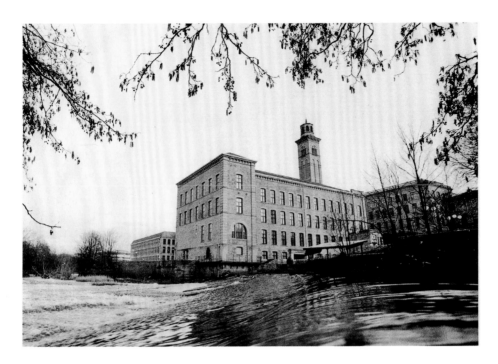

**New Mill 1890**

The chimney was modelled on the bell tower of the Venetian church of Santa Maria Gloriosa and was much praised by John Ruskin at the time of its construction. New Mill 2009. Derelict and rat infested a decade ago, the building now houses Riverside Court apartments overlooking the weir and the park. The building also incorporates the headquarters of Bradford's District Care Trust.

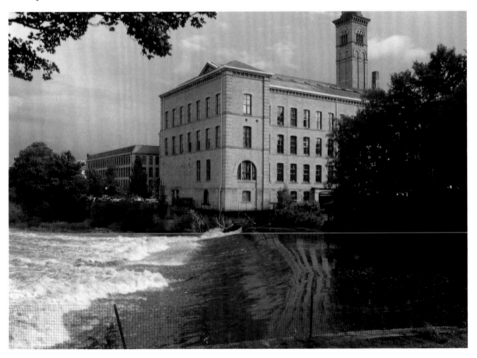

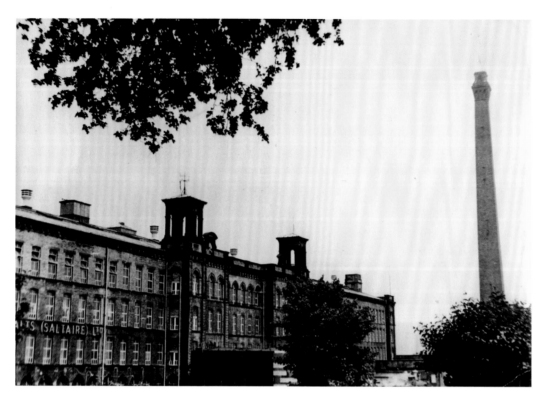

**South Front of Mill** *c.* 1968
This time showing the original (150 ft) chimney stack, with an elaborate Tuscan styled cornice. Below is the same viewpoint in 2009 but including the original workmen's allotments in the foreground. The chimney lost its Italianate summit in 1971 on safety grounds.

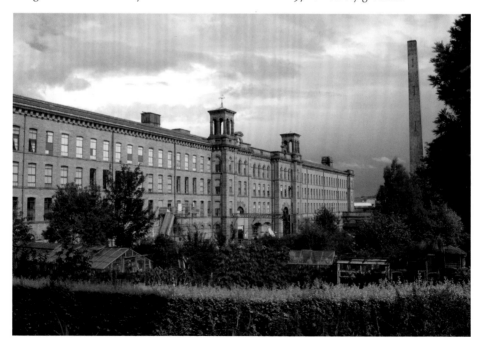

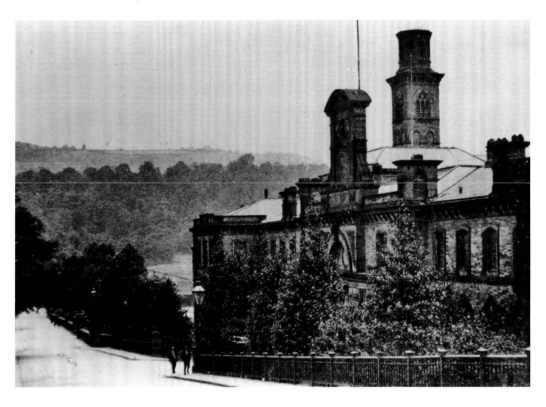

## Mill Offices c. 1900

This office block (right) was part of the original mill overlooking Victoria Road and the Congregational Church. The projecting gable (centre) housed Salt's personal office with its private entrance. The corniced roof line is taken up by three bell turrets to summon and dismiss shifts to and from the mill. In the background is Baildon Moor and Shipley Glen. Mill Offices 2010. Victoria Road is no longer carried across the river Aire as in the photograph above but ends abruptly at the New Mill entrance (far left).

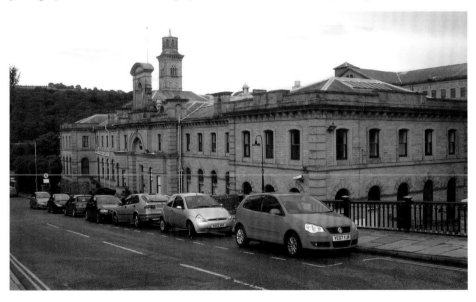

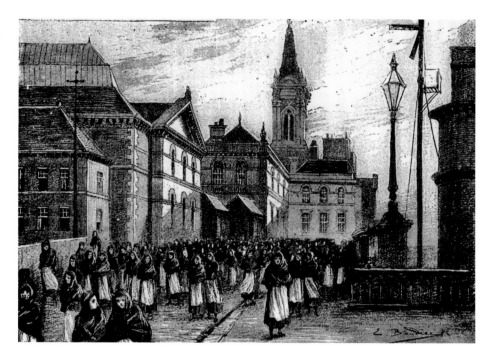

## Victoria Road

Mill girls in Victoria Road *c.* 1880. When the mill first opened, 2,500 workers were transported into Saltaire by the recently opened railway. These railway 'specials' were hired by Salt to coincide with shift hours at the mill. Spinning was mainly a female occupation and these beshawled young women have just left the station entrance (right) heading in the direction of the main entrance to the mill. In the distance are the Victoria Hall (1871) and the Sunday school (1876). Only just visible are the operating ropes for the Victorian railway signal. The mill girls have long gone now but the railway station entrance is still to the right. Tree cover hides the Victoria Hall and cars take up the road instead of workpeople. The Sunday school was demolished in 1972.

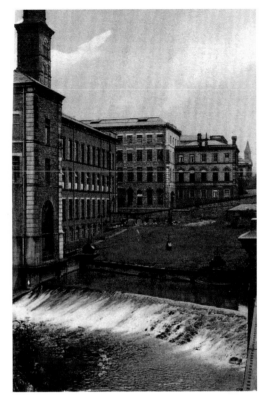

**New Mill and Weir** *c.* 1900
This Italianate style spinning mill was
erected by Salt in 1868 to make use of excess
steam power and produce more yarn for his
voracious weaving machines. It occupies
the site of the original Dixon's mill a corn,
and later, a fulling mill, of the eighteenth
century. The original mill weir was replaced
and enlarged in 1871 by the current
structure which here, is in full spate at the
height of recent flooding of the River Aire.

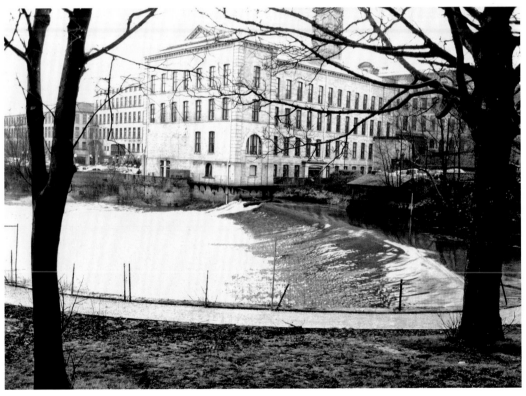

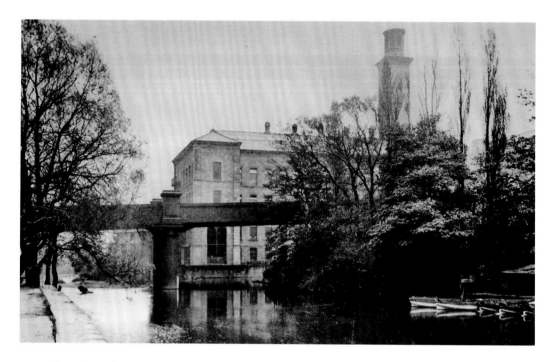

### Victoria Bridge

Victoria Bridge *c.* 1930 from the canal bank looking eastwards to the New Mill. This bridge of (tubular) cast iron carried Victoria Road over the river Aire towards Salt's coach road at Milner Fields. During the twentieth century it also gave access to the beauty spots of Shipley Glen and Baildon Moor for thousands of holiday makers from the centre of Bradford. To the right is the boat house. Below is the same view in 2009, but the bridge was demolished in 1962 and replaced by a footbridge. The original boathouse burned down in 2007 but has since been rebuilt as the Boathouse Inn.

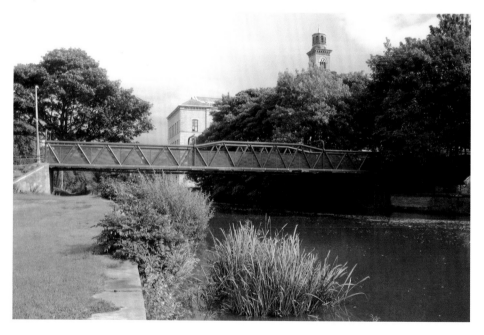

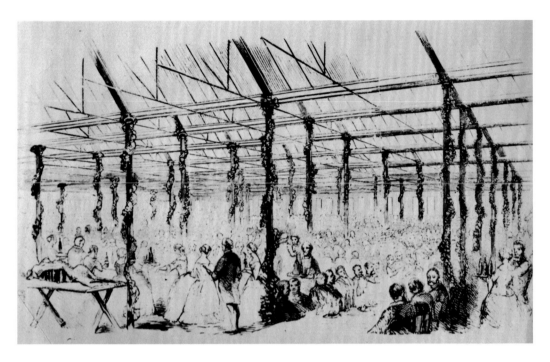

### The Mill Restaurant

Dining at the Mill opening in 1853. This took place on Salt's fiftieth birthday, 20 September 1853, in the combing shed of the mill which accommodated 3,500 invited guests including 2,440 of his work force. Salt's Diner 2009 is part of the original West Mill (spinning). This popular restaurant is now a favourite with locals and visitors and overlooks Salt's combing shed of 1853.

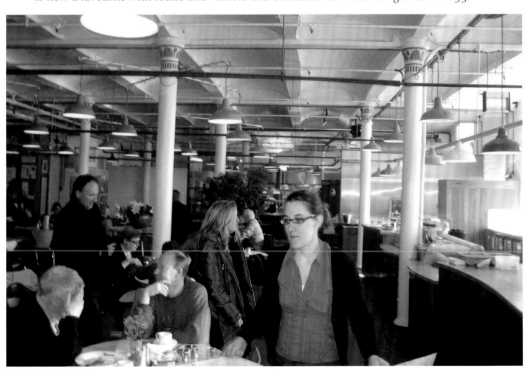

# PLAN OF ORIGINAL VILLAGE

Q — ALBERT ROAD — O

P

GORDON TERRACE
DOVE STREET
JANE STREET
SHIRLEY STREET
TITUS STREET
CAROLINE STREET

MARY STREET    FANNY ST.

HELEN STREET    EDWARD ST.

N

ADA STREET    AMELIA ST.

R    M

GEORGE STREET

S    I

T    X    J

Z    Wm. HENRY ST.    H

K    B

VICTORIA ROAD    U V

Almshouses    Y    L

W

KEIGHLEY - BRADFORD ROAD

EXHIBITION ROAD

Site of Royal Yorkshire
Jubilee Exhibition 1887

RAILWAY    MA

TO LEEDS

Chimney

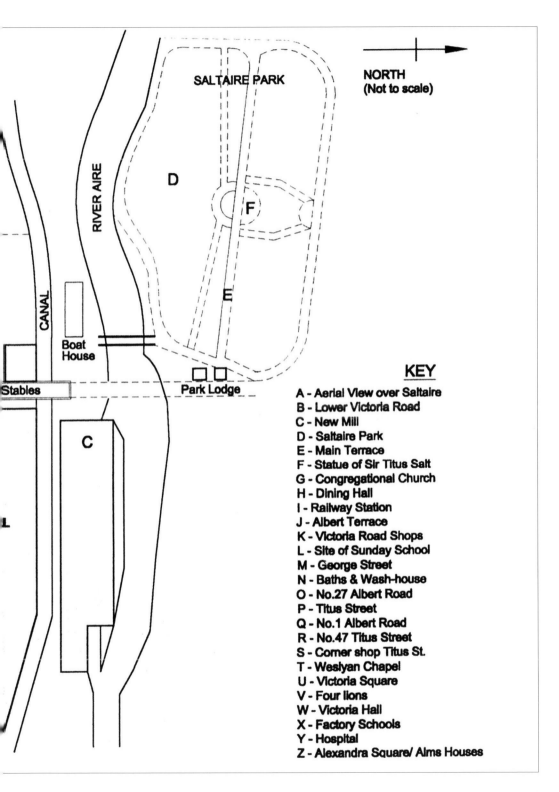

SALTAIRE PARK

NORTH
(Not to scale)

RIVER AIRE

CANAL

D

F

E

Boat House

Stables

Park Lodge

C

L

**KEY**

A - Aerial View over Saltaire
B - Lower Victoria Road
C - New Mill
D - Saltaire Park
E - Main Terrace
F - Statue of Sir Titus Salt
G - Congregational Church
H - Dining Hall
I - Railway Station
J - Albert Terrace
K - Victoria Road Shops
L - Site of Sunday School
M - George Street
N - Baths & Wash-house
O - No.27 Albert Road
P - Titus Street
Q - No.1 Albert Road
R - No.47 Titus Street
S - Corner shop Titus St.
T - Weslyan Chapel
U - Victoria Square
V - Four lions
W - Victoria Hall
X - Factory Schools
Y - Hospital
Z - Alexandra Square/ Alms Houses

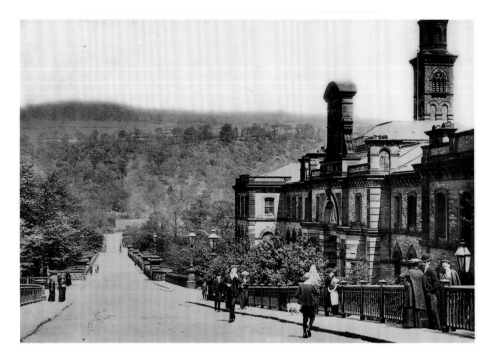

## Victoria Road (Lower)

Part of the original (1853) mill this office block overlooks the lower stretch of Victoria Road. To the left of the photograph is the entrance to the Congregational Church. Here the road leads to the cast iron bridge over the river (vis 12 top). Here, in 2009, the office entrance is much clearer showing Salt's office (gable) and Board Room (bay window to the left of the entrance. The mill offices are now occupied by PACE, the world wide microtechnology business.

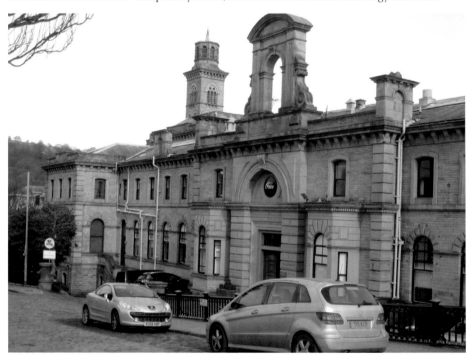

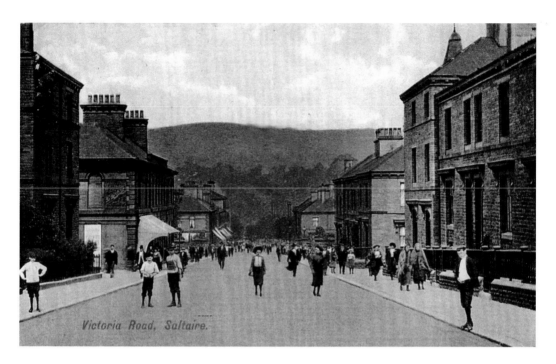

Victoria Road, Saltaire.

## Victoria Road (Upper) *c.* 1910

A photograph taken from the junction with the main road to Shipley and Leeds, looking north. For the first generation of residents, the width of this road contrasted sharply with the narrow alleys and lanes of mid Victorian Bradford. In the distance Baildon Moor and Shipley Glen provide a brooding rural background. The number of well dressed young people in the street would suggest a holiday or Sunday when the photograph was taken. This is still the major highway in Saltaire although it now provides more for road traffic and tourists than for pedestrians and workpeople.

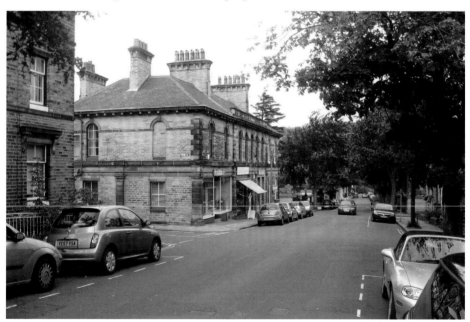

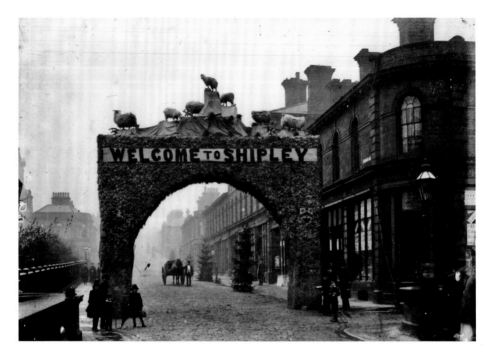

### Victoria Road (Lower) 1887

This temporary triumphal arch was part of the Yorkshire Jubilee Exhibition of that year. Approaching the arch (and the mill entrance) is a horse and cart probably carrying wool or cloth. To the right is Albert Terrace and the railway station. As in the photograph above the shops here continue to be the main retailing sector of Salt's model village. Today however, bistros, cafes, and designer clothing outlets have replaced the traditional bakery, butcher's and greengrocery shops of Salt's day.

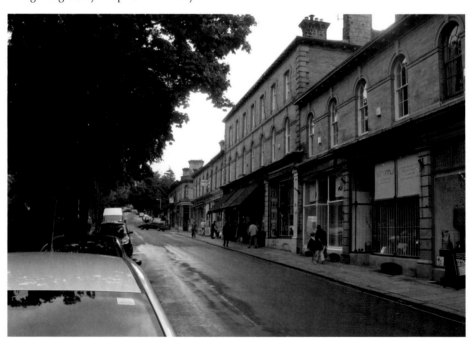

**Victoria Road Shops** *c.* 1960

Despite corner shops being distributed in amongst the streets and homes of the workpeople this parade of eleven shops was the main shopping precinct in the original village. The second and third storeys of this block of shops (built in 1853) were temporarily used as a public institute and community centre prior to the erection of the Victoria Hall in 1871. Apart from the purpose and character of the individual premises, there is little change in the modern view.

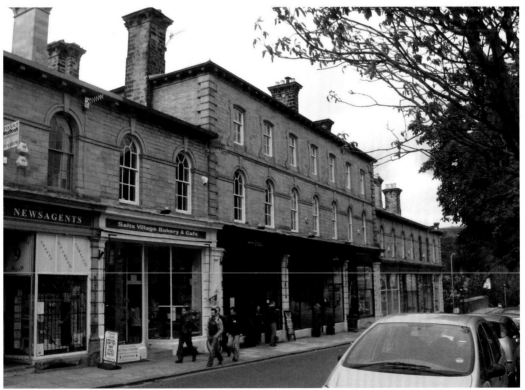

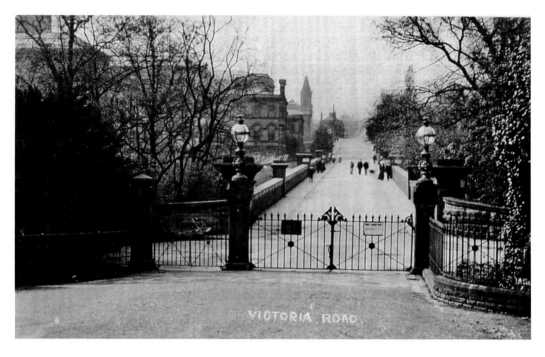

### Victoria Road, North End *c.* 1900

The gates originally prevented public access to Titus Salt's private coach road to Milner Field, but here they are leading off to the right and the main original entrance to the park. The closure of the bridge in 1962 meant a new footbridge and park entrance. Today, much of Victoria Road is lost in tree cover.

**Albert Terrace c. 1984**

This wonderful 'Brandtesque' photograph from the camera of Ian Beesley captures the rain washed cobbles of what is known locally as 'the railway bottom'. This was part of the first stage of house building in Saltaire and was completed in 1854. It took in all the streets between Caroline Street and Albert Terrace and between Victoria Road and Herbert Street. To the right of both photographs are the three storey boarding houses at the end of George and William Henry Streets. These are also a feature in Caroline Street where their height relieves the monotony of the villages' grid arrangement as well as providing useful lodging accommodation during the transitional period of Salt moving his business out of Bradford.

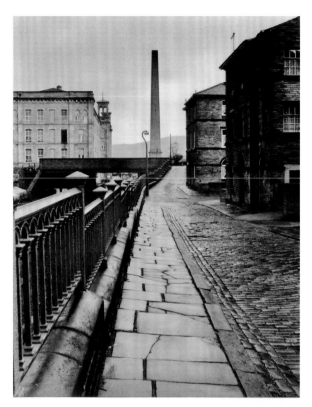

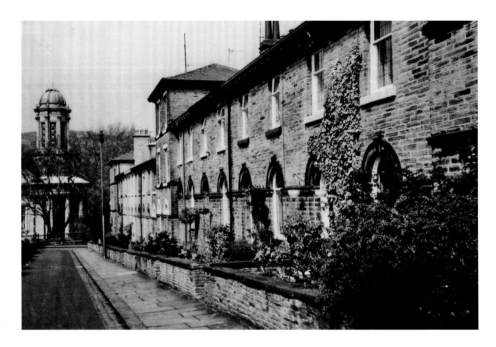

**George Street** *c.* 1950

These overlookers' cottages (also in William Henry Street) generally consisted of scullery, kitchen, living room, cellar, and 2-3 bedrooms. Running north to south the complete length of the village, this street originally afforded travellers on the Bradford road a view of Salt's magnificent church and tower. Particular to this street and visible here are the small apron gardens in front of each house. Also included in this first building phase (1854-1858) were the standard workmen's cottages of Amelia, Edward, Fanny and Herbert Streets. Plain in their design, they cost Salt £120 each to build but were of a far higher standard at that time than those available in nearby towns like Bradford and Shipley. There were no back to back terraced homes in Saltaire.

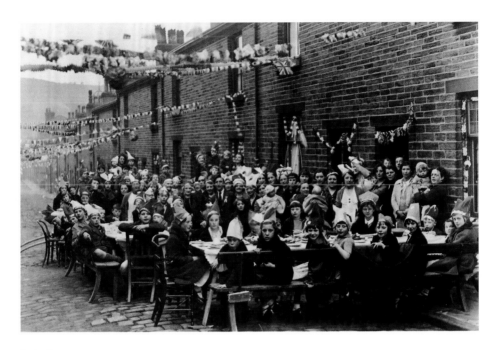

## Ada Street

Coronation party 1937. This street of housing was typical of the second building phase of workpeople's homes, located between Titus and Caroline Streets including Whitlam, Mary and Helen Streets. They were completed in 1857 at a cost of £250 each but were almost identical to those of the first phase. These homes are now subject to Grade II by-laws, and as a result are little changed. Their narrow back alleyways were designed originally for the removal of nightsoil from outside privies but in 1993 were used to accommodate cable technology and allow owners access to the information super highway.

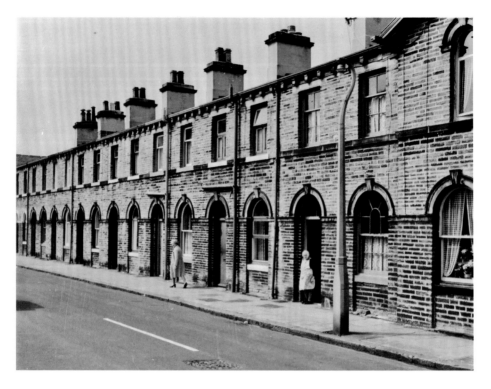

Titus Street c. 1950

This later type of workpeople's cottage built during the 1860s along one of Saltaire's principal highways, shows an improvement in architectural detail to sash windows and doors, and an increase in size to three bedrooms. Note that properties at the end of each row have overhanging eaves to the gables, this row was originally built in the shadow of the Wesleyan Methodist Chapel (to left) but today has a much more open aspect owing to the chapel's demolition in 1973.

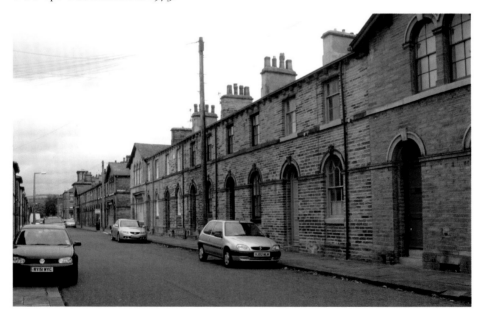

**Belvedere in Titus Street *c.* 1960**
Having completed the housing north of Caroline Street in 1857, Salt and his architects decided to layout those streets between Leeds Road and Titus Street. By running across the slope of the land rather than up and down it, the houses were visually more pleasing to passers by. At 47 Titus Street, almost at the very centre of the village, the roofline is broken by this windowed viewing tower or belvedere whose purpose is in doubt. As this house in 1871 was occupied by Sergeant Major Hill; who, (as an ex-policeman) was commissionaire and security officer at the mill, the house is likely to have been nothing more sinister than a fire watching tower for the village.

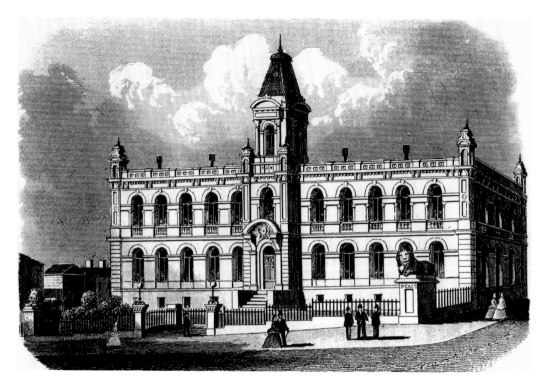

**Victoria Square** *c.* 1888

This square in Lower Victoria Road is marked at its four corners by the lion statuary of Thomas Milnes. The lions represent War, Peace, Vigilance and Determination. They are thought to have been originally sculpted for the Nelson monument in Trafalgar Square, London. As in the image above, the square is dominated by the Victoria Hall and Institute which is flanked by Lockwood Street and Mawson Street, named after the architects of Saltaire.

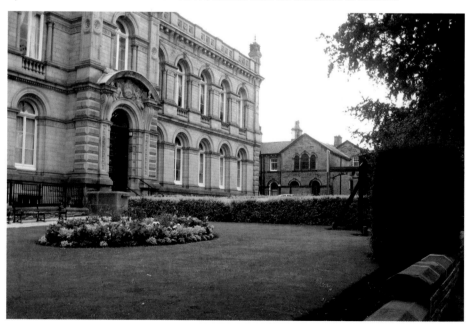

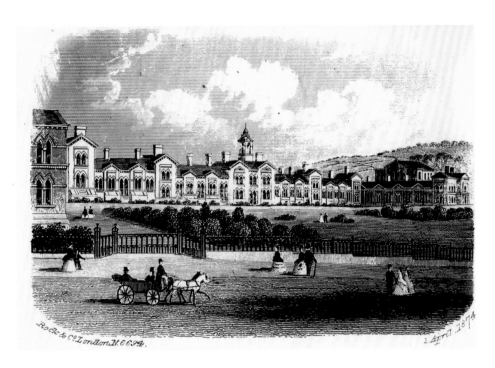

## Alexandra Square

In the upper part of Victoria Road can be found a second public square within the confines of forty-five almshouses for the elderly, all built in the Venetian gothic style. All are single storey with the exception of two on the east and west sides facing each other. Those on the western side house a bell turret and under their gable ends are the monograms of T. S. and C. S. carved in stone (Titus and Caroline). These buildings came with a weekly pension of 7s 6d for a single person and 10s for a married couple. They are still used by Bradford Council as homes for the elderly and still provide an oasis of quiet and greenery within the village.

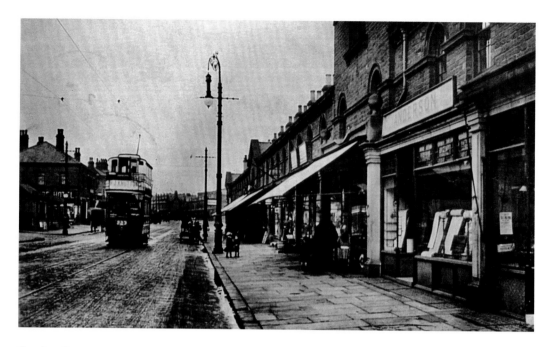

Gordon Terrace *c.* 1914

Municipal public transport schemes came with the growing conurbations of Shipley and Bradford after 1900. The buildings at the southern end of Gordon Terrace were probably built as shops in 1869. However, the dozen or so three storey buildings at the far end of the terrace were built originally as overlookers' houses in 1868 and converted to shops prior to 1914.

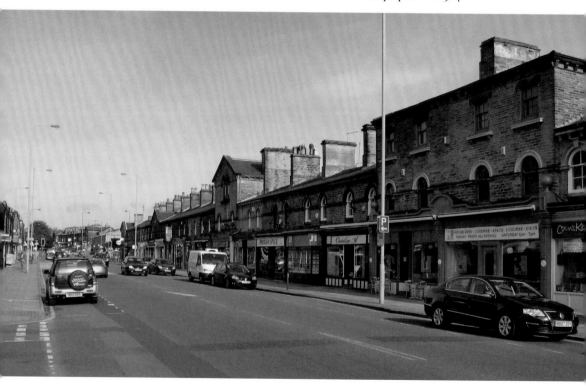

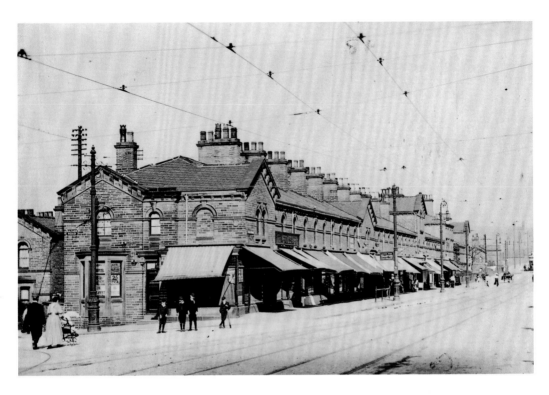

**Gordon Terrace**

This housing became a second retailing sector for the model village. A century later their fashionable and modernised appearance have made this a popular attraction for visitors and tourists alike.

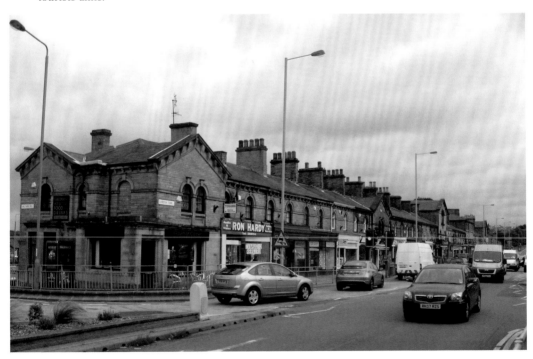

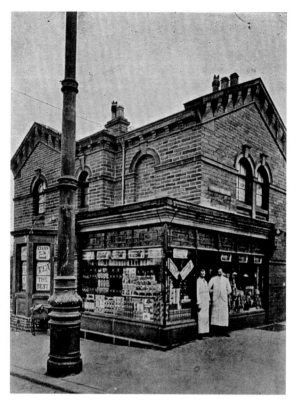

**Charlesworth's Shop** *c.* 1914
This grocery store at the junction
of Gordon Terrace and Saltaire
Road had been popular with
Saltaire's Edwardian shoppers. John
Charlesworth (outside his shop) had
first begun retailing as a flour dealer
at No 1 Victoria Road in 1880. 24
Gordon Terrace served for much of
the twentieth century as an agency of
the Halifax Building Society, but has
recently become 'Gourmet Corner', a
delicatessen and café.

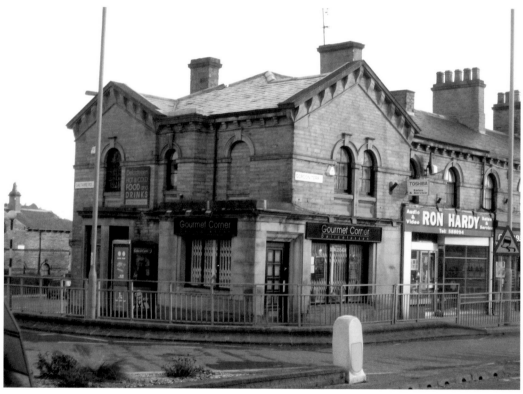

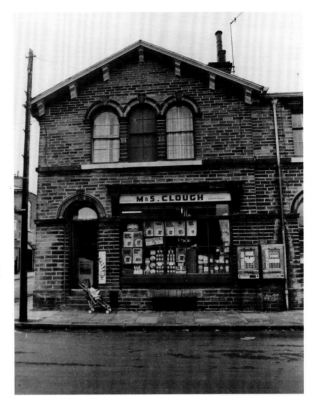

**Corner Shop Titus Street** *c.* 1960
This is one of several purpose-built street corner shops scattered around the village. Salt personally vetted all those tenants who ran shops although he never interfered in their commerce. By 1870 there were forty such shops scattered around the village, but here Mr Clough's premises have reverted to a house in recent years.

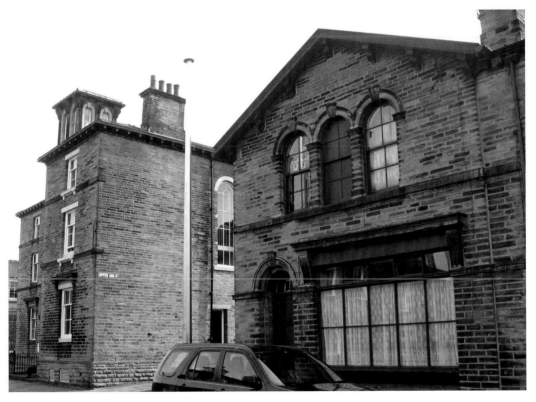

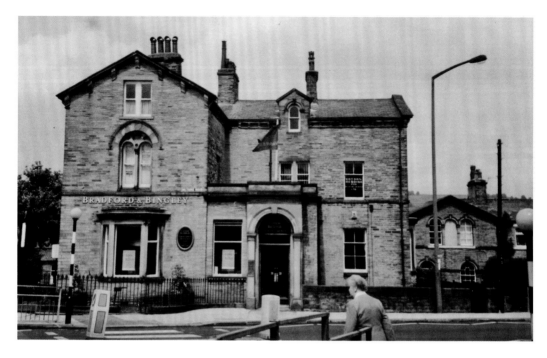

## 1 Albert Road *c.* 1970

This was the largest private house in the original village and incurred an annual rent of £18 (7 shillings per week) and according to the 1871 census was occupied by Fred Wood, chief cashier at the mill. It later became a branch of Lloyds Bank and more recently a branch of the Bradford and Bingley Building Society. Following the recent demise of the building society this house is now occupied by a local firm of insurers and the Santander Group.

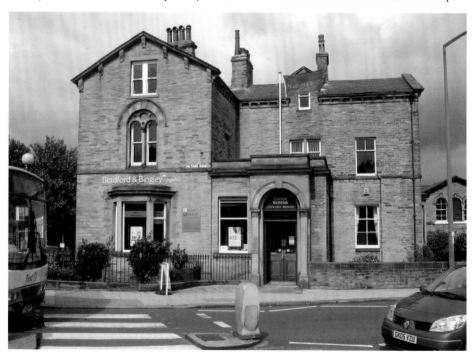

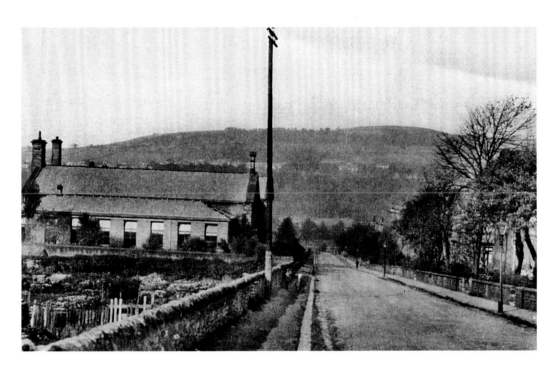

Albert Road c. 1900

This road was built in 1868 as part of the final phase of house building. This is the western boundary of the village. The houses on the right accommodated professional men and their families not always associated with the mill e.g. teachers, civil servants and men of the cloth. For a weekly rent of between 5 and 7 shillings they offered two cellars (one for coal, one as a cooler) a large kitchen, parlour, living room and four bedrooms with two gardens and a yard at the back. At the lower end of Albert Road such houses were built as semi-detached or in a terrace of four for mill executives.

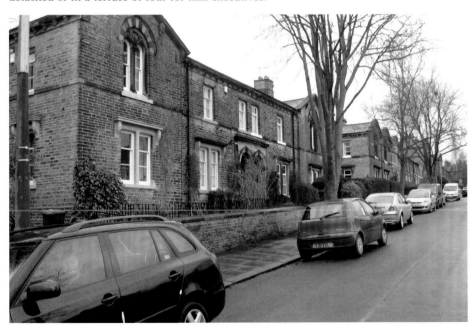

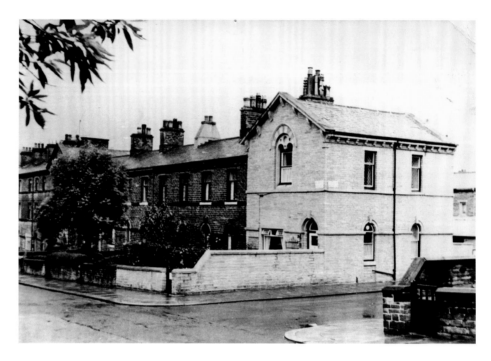

**Albert Road** *c.* 1975

A stone cleaning programme by Bradford MDC in 1974 distinguishes this foreman's cottage at the corner of Titus Street and Albert Road, from the row of eighteen overlookers' cottages alongside. The same house has become further gentrified by the invasion of ivy and privet hedges. Until 1933 all these houses overlooked the green fields of the Aire valley and faced the setting sun. They offered a wonderful prospect for those who could afford the relatively modest rent which Salt charged.

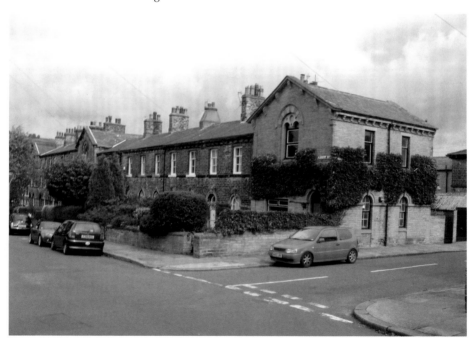

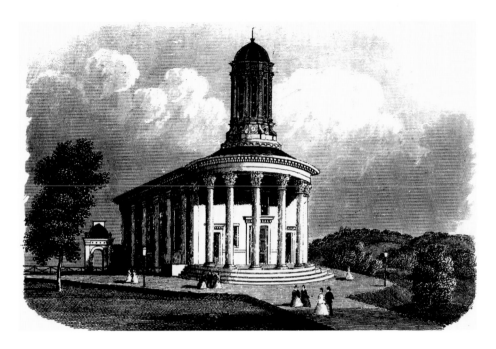

## Congregational Church

This church (opened in 1859) was Saltaire's first public building to be completed at a cost to Salt of £16,000. It is built in the Classical style. Inside, there are no aisles and tall pilasters of green scagliola soar up to the barrel-ceiling. Here to the left of the building is the Salt family mausoleum. The avenue of tree cover leads the eye easily up to the magnificent circular domed tower supported by a semi-circular portico resting upon huge Corinthian columns. Titus Salt was a life-long Congregationalist who believed his commercial success was God-given hence the church's location opposite the mill and its offices.

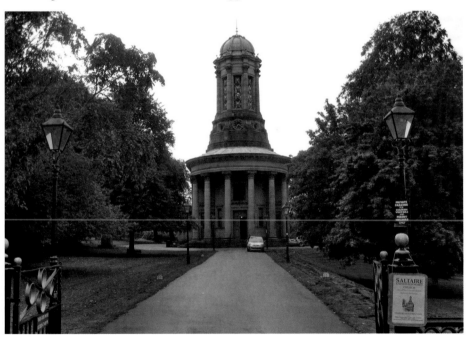

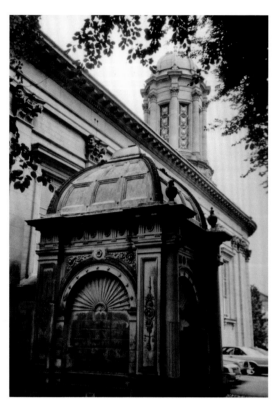

## Salt Mausoleum

In January 1877 Salt was interred here at the mausoleum, adjoining the church. His funeral cortege was followed by representatives from all the groups, clubs and societies with which he had been associated. The hearse left Crow Nest at 9.30 am 5 February 1877 and passed 100,000 mourners before arriving here at Saltaire via Bradford's Town Hall Square and Manningham Lane. Those wanting to pay tribute were so great that the Mausoleum was kept open to the public until 13 January 1877. Here, are also buried Salt's wife Caroline and their children Fanny, Whitlam and Mary as well as their youngest son Titus jnr. and his wife Catherine (died 1903). Curiously, this small plot of land and monument is now thought to be the only property in Saltaire still belonging to the Salt family.

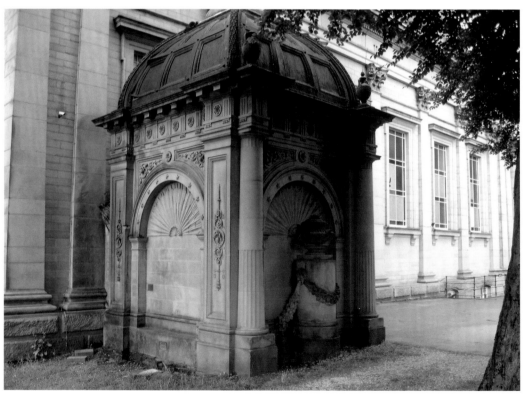

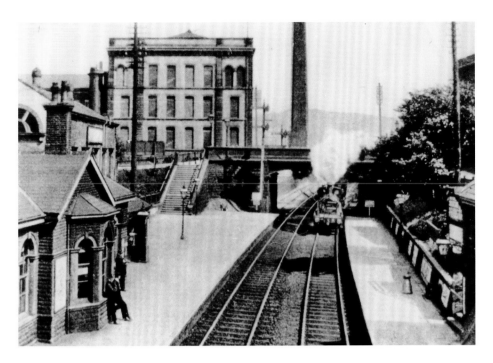

Railway Station c. 1900

As part of the recently opened (1846) Leeds to Skipton line, this original station was built by the Midland Railway in 1859 but in keeping with the Italianate style favoured by Lockwood and Mawson throughout the village. The convenient little station survived virtually unaltered until the 'axe' of Mr Beeching, who closed it in 1965, it was then demolished in the 1970s. By 1984, the West Yorkshire passenger transport group, decided to reopen a station as part of Saltaire's regeneration plan. It has become a well used station particularly by those who commute daily to work in Leeds. Here, an electric train of Northern Rail passes through the station on its way to Leeds.

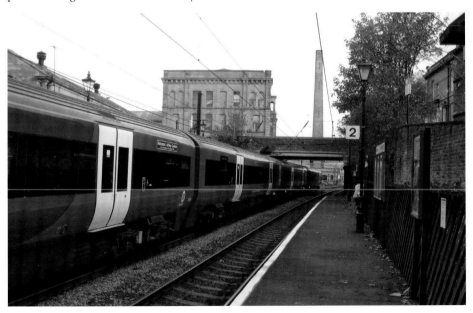

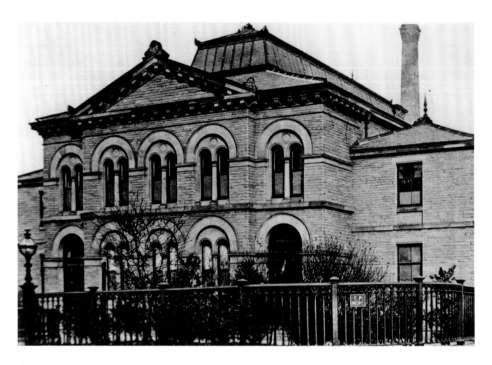

**Sunday School c. 1968**

This was the last of the public buildings to be erected in Saltaire. It was on a site, opposite the main parade of shops, in Victoria Road. It was originally intended as a site for a hotel. The cornerstone of this building was laid by Salt's grandsons Gordon and Harold. It cost Salt £10,000 and could accommodate 800 scholars. Your author has fond childhood memories of spring fayres, Christmas bazaars, choral events in this building but all went into the dustbin of history in 1972 when the it was condemned as structurally unsound and demolished rather quickly. The site has since become a much needed car park for visitors to Saltaire and an even more necessary block of public toilets which can be seen here through the entry. From planning to completion, the toilet block was erected in three years, the same length of time as it took to build the original mill in 1853.

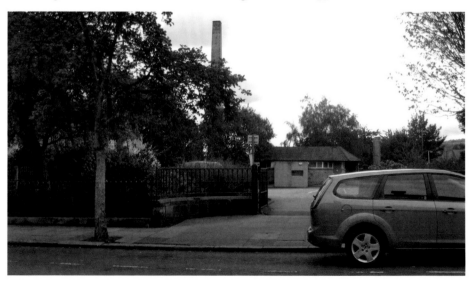

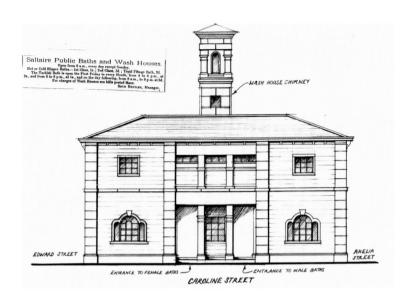

Saltaire Public Baths and Wash Houses.

Open from 8 a.m., every day except Sunday.

Hot or Cold Slipper Baths.— 1st Class, 1s.; 2nd Class, 3d.; Tepid Plunge Bath, 2d.

The Turkish Bath is open the First Friday in every Month, from 4 to 6 p.m. at 2s., and from 6 to 8 p.m., at 1s., and on the day following, from 8 a.m., to 8 p.m. at 6d.

For charges of Wash Houses see bills posted there.

Seth Bentley, Manager.

WASH HOUSE CHIMNEY

EDWARD STREET

AMELIA STREET

ENTRANCE TO FEMALE BATHS

ENTRANCE TO MALE BATHS

CAROLINE STREET

## Baths & Wash House

There is no extant photographic evidence of this building opened in July 1863. This is a conjectural illustration drawn by a professional architect from a surviving set of original plans. They reveal the prevailing Italianate design around Saltaire as well as a small campanile chimney stack for the boiler house. The buildings were located in a small square along Caroline Street and between Edward and Amelia Streets. Salt loathed the idea of public washing in the streets, and paid £7,000 for their erection. By the early twentieth century several of the rooms here had been converted to lodgings or extra homes. Originally (because Salt's housing did not include indoor bathrooms) he provided twenty-four baths (twelve for men and twelve for women) on opposite sides of the building. A warm bath cost sixpence and a cold one 3d. They were open daily except Sunday 8.00 a.m. – 8.00 p.m. There was also a Turkish bath. The washhouse housed forty-eight washing, rinsing and steam tubs, forty-eight drying closets, mangles and a centrifugal wringing machine worked by steam. As in other parts of the country, public washing was never popular. The building and area around it soon had a poor reputation and in 1936 it was demolished. Today, a wild shrubbery hides a rather dismal row of garages choked in barbed wire. Today's Saltaire working residents have access to a modern launderette service in Leeds Road.

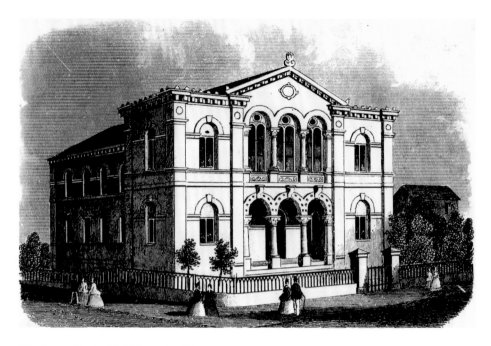

### Wesleyan Methodist Chapel 1868

This building is another of the designs of architects Lockwood & Mawson. It was originally financed by subscriptions and collections although Salt gave the land and personally laid the foundation stone in 1866. It played an important role in community life between the wars but was demolished in 1970 as its congregation had severely dwindled. This view is from Saltaire Road. The growth of secular Britain since 1945 and the general decline in Sunday worship across most Christian religious groups meant a rethink by the Wesleyan Methodists of Saltaire in 1973. In place of the gloomy grandeur of the old chapel they preferred the modesty of a small church hall for worship and an adjoining community centre. Both can be seen here from Titus Street.

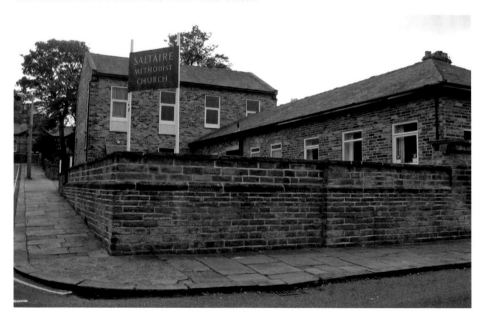

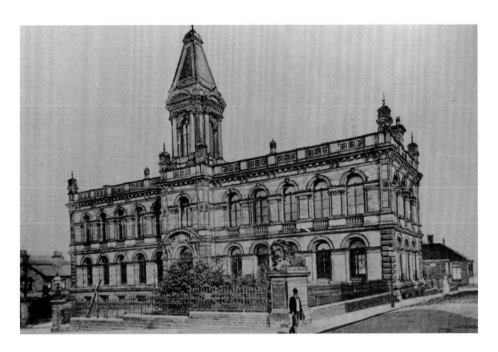

**Saltaire Club and Institute (Victoria Hall)** *c.* 1900

This well proportioned building makes up the east side of Victoria Square and faces the Factory schools. It was completed in 1871 and cost Salt £25,000. Membership was cheap and it provided a home for numerous clubs and societies in the village. The gentleman in the foreground stands before one of the Saltaire 'lions' – 'Peace'. For part of the twentieth century it served as a public library and dance hall for the tax payers of Shipley and west Bradford. The main Victoria Hall is still used for concerts today. Part of the building is home to Phil Fluke's large collection of harmoniums and reed organs which is open to the public.

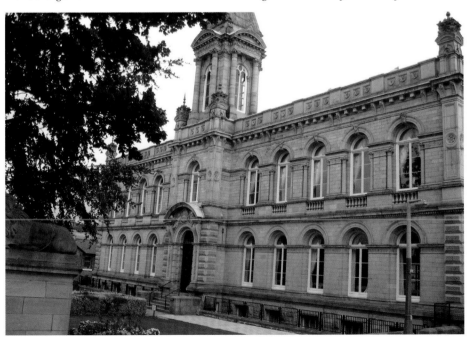

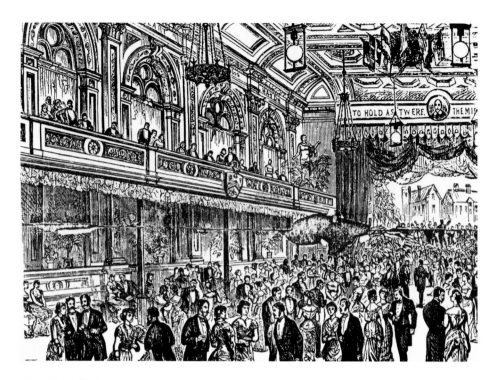

## Victoria Hall 1872

Here is the grand opening of the Hall and Institute in June 1872. Guests and workpeople were invited to a magnificent ball and musical concert. From here, Titus jnr. later gave slide shows of his travels around Europe and the Middle East; also from here his wife Catherine, ran a well supported class in cottage cookery. In 2010 bunting is out in the hall to host yet another important event in Shipley's social calendar. The decorative plasterwork of the ceiling can be seen in both images. In 1992 Bradford council completed a wide programme of repairs and redecoration of this hall.

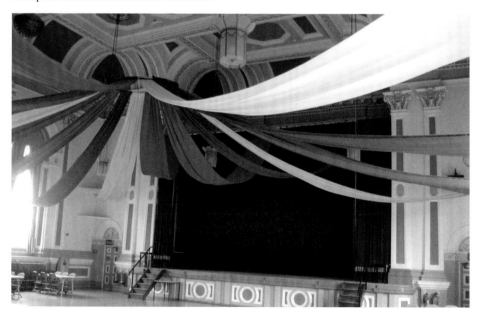

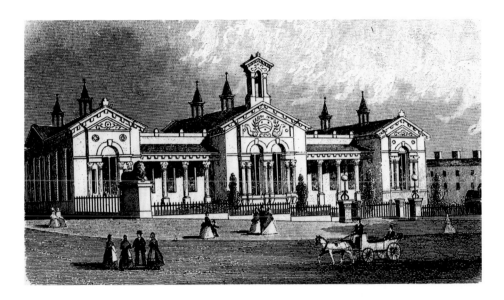

## Factory Schools

They were erected in 1867 and opened in the following year. They made up the western boundary of Victoria Square making the area a precinct of learning and culture. Once again the Italianate style prevails in the colonnaded façade with its Corinthian pillars and window pilasters. Much of the ornamental stonework in the triangular pediment of the central gable makes up Salt's coat of arms and was the work of Thomas Milnes. Here are two more of Milnes's Saltaire Lions-Vengeance and Determination. Following the work of Salt's good friend and fellow liberal W. E. Forster in the 1870 Education Act, these schools, immediately after their completion, came under the control of the Shipley School Board. By setting up a charitable trust Titus Salt jnr. regained their control by creating the Salts High School for boys and girls. They later became Salt's Grammar School but are now part of Shipley College.

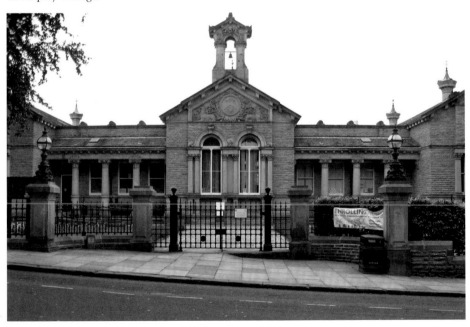

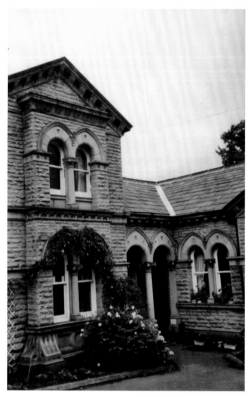

## Almshouse Chapel

Adjoining the hospital and making up an attractive square (Alexandra) of shrubs and ornamental gardens were forty five almshouses. The original buildings were opened in September 1868 and came with a weekly pension for former employees in need (see page 27). Here in the north west corner of Alexandra Square a single dwelling served as a private chapel for elderly residents to save their weary limbs on winter Sundays. This remains a quiet and secluded corner of Saltaire but the chapel has now gone and reverted to an extra almshouse.

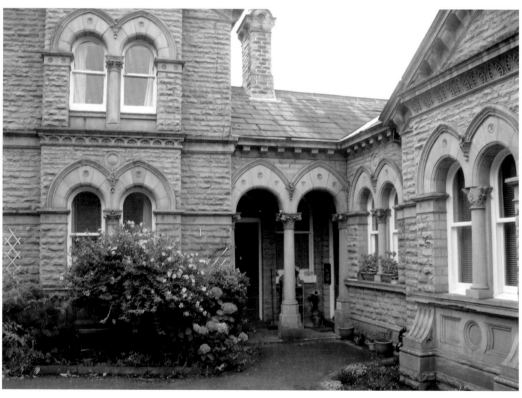

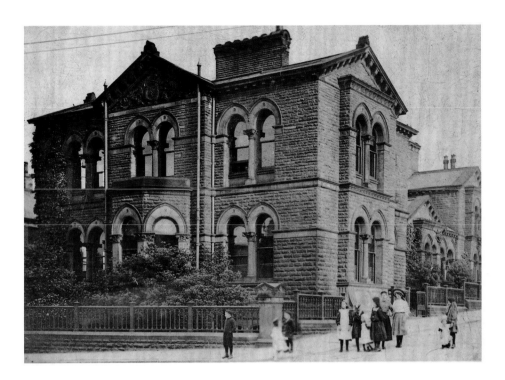

Saltaire Hospital *c.* 1890

Originally this was a small two storey hospital of six beds built at the north east corner of Alexandra Square adjoining the Leeds Road (seen here in foreground). It was opened in 1868 essentially as a casualty ward for accidents at the mill. Exactly a century ago it was extended to seventeen beds on three floors. It served as an auxiliary hospital in 1914-18, further extensions up Victoria Road in 1926/7 increased its beds to twenty-four. Developing into a cottage hospital for the whole community, it finally closed as a hospital in May 1979 and is now retirement apartments.

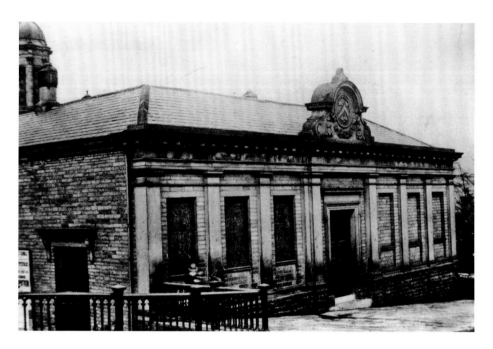

### Dining Room *c.* 1900

Adjacent to the railway station is the former Works Dining Room built in 1854 to cater for those who travelled into the mill from outside the village. It can also be accessed by a tunnel under the road into the mill yard. It cost Salt £3,600 and it catered for 800 diners. In the early days it was well used and served as both church and school at one time. By the turn of the twentieth century it became redundant as workers preferred to eat at home. Today it continues to serve the community as an administrative centre of the Shipley College. Above the doorway is a large stone medallion bearing Salt's coat of arms. To the left is the ramp down to the new railway station. Peeping above the roofline is the tower of the church.

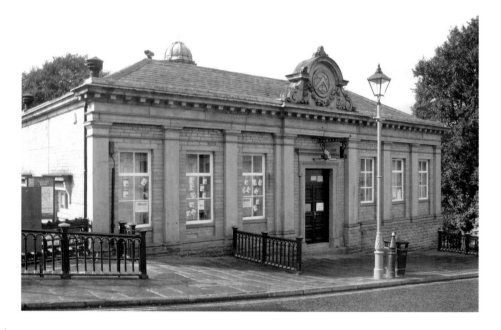

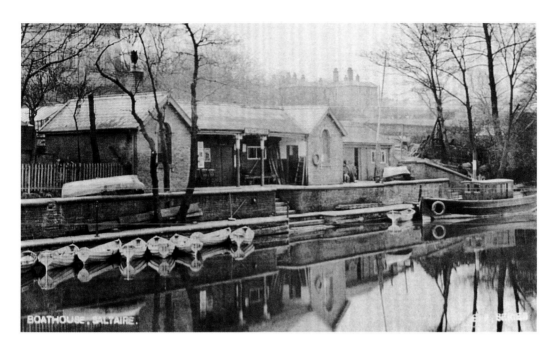

**The Boat House _c._ 1900**

This had been built in 1871 about the time of the opening of the park. That year was also when old Dixon's Mill weir was replaced and the river widened at this point to facilitate swimming and leisure boating. The original boat house remained closed and unused for many years until a local restauranteur converted it into a restaurant and bar. This was badly gutted by fire in 2007 but recently reopened as a pleasant watering hole for residents and a good quality bistro for visitors and tourists.

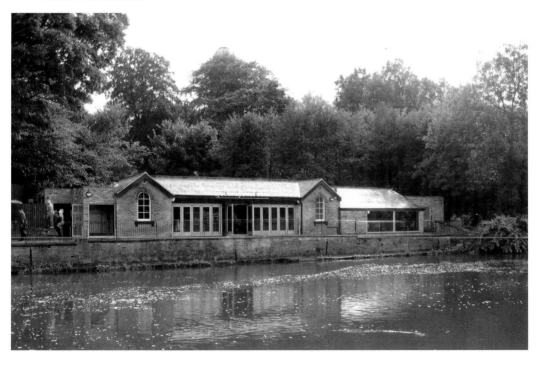

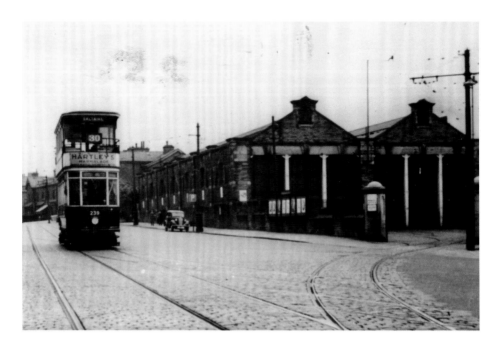

**Tram Shed**

Technically not part of the original Saltaire but a significant landmark within its geography nevertheless. It was opened by Bradford Corporation Tramways in 1904. The council had run steam trams in this direction since the 1880s via Bradford Road and electric trams to Saltaire from 1902. The depot building housed thirty tram cars until 1939 when it became a trolleybus service until 1978. After that came the motorbus, much later it housed a children's indoor adventure play area and more recently has become the 'Old Tramshed', bar and brasserie. To the left is the A650 Bradford-Keighley road and to the right of camera in the lower image is the top of Albert Road and a car park for the 'Old Tramshed'.

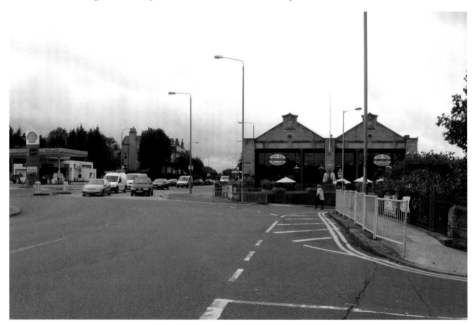

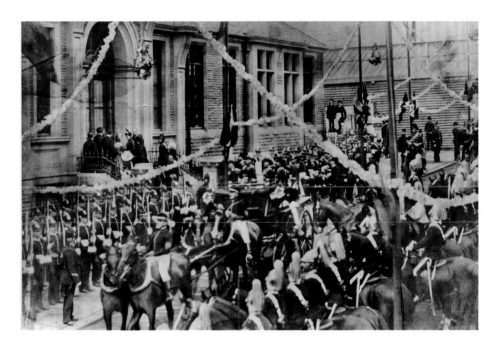

### Exhibition Hall 1887

This was built in that year as a Science and Art school to extend the Victoria Institute facilities. It was partly funded by taxpayers and dedicated as a memorial to Sir Titus Salt. The Royal Yorkshire Jubilee Exhibition took place here at Saltaire in the summer of 1887 when Princess Beatrice, the youngest child of Queen Victoria, officially opened the proceedings. Here Titus jnr. and his family welcome their royal guests on the steps of the new building. Top right is the main public entrance to the exhibition proper. The Hall became the main building of the Shipley College during the twentieth century and remains so to this day. The college offers a wide range of vocational and further education courses for the young people of the locality and serves local residents as a community venue e.g. here at the annual seed potato event in 2010 below.

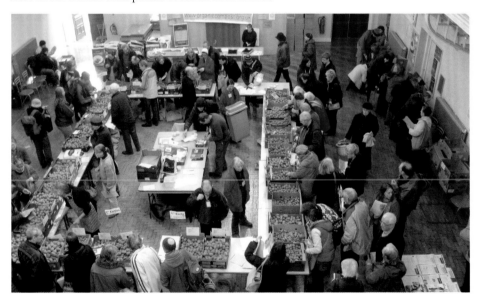

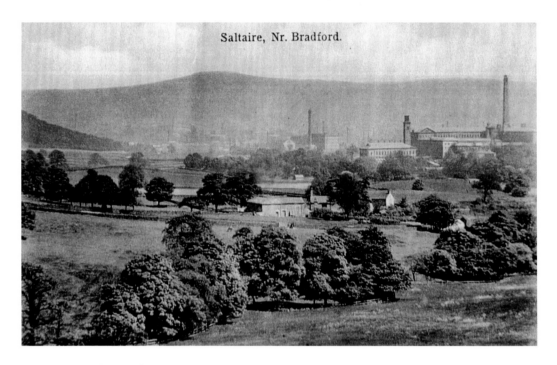

Saltaire, Nr. Bradford.

## Saltaire from the North West *c.* 1870

As Titus Salt's mill and village neared completion by 1870 it was fitting that the family of Saltaire's paternalistic benefactor should live nearby. Sir Titus was already well established at Crow Nest near Lightcliffe so in 1871 he purchased for his youngest son Titus the modest estate of Milner Field, a mile north west of Saltaire and in a commanding position overlooking the river Aire. From the new house of Milner Field, mill and village were clearly visible to the family. After 1930 this fine Victorian mansion fell into disuse so that today there is very little evidence left of it, and the view of Saltaire is lost by excessive tree cover and empty pastures.

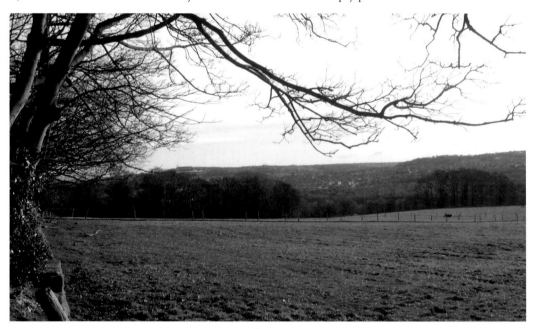

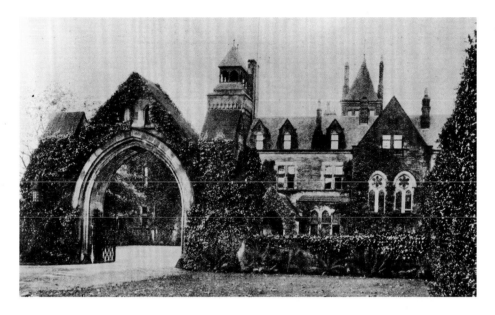

Milner Field *c.* 1873

There had been a yeoman farmhouse on this site since the early seventeenth century. Titus Salt purchased the site of 45 acres and built what one writer has described as a 'Wagnerian Gothic Retreat'. Here a circuitous drive through woodland ends at the forbidding entrance into the rear courtyard. In 1873, originally the house had every conceivable modern convenience and the interior was magnificently furnished with walnut and chestnut panelling to most rooms. Thomas Harris was the architect and he included a huge conservatory for ferns and fruits, palms and orchids, the cultivation of which the young Titus Salt had followed in his father's footsteps. Managing directors of the company lived here until the 1920s. It was for sale in1930 but failed to attract a buyer. By 1950, it was derelict and was later demolished. Here, early spring sunshine falls upon what remains of the entrance archway (centre).

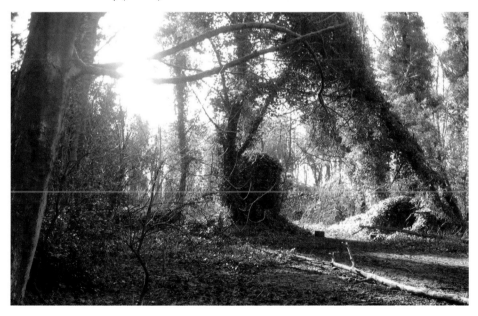

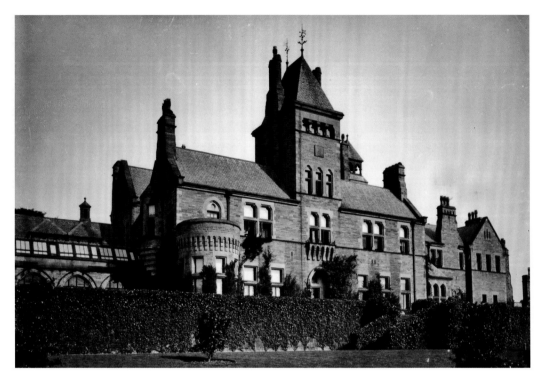

**Milner Field, South Terrace** *c.* 1920

To the left was the conservatory and where the house adjoins it was the private study and bedroom used by the Prince of Wales on his visit in 1882. Here, is what we think remains of the south terrace at the front of the house.

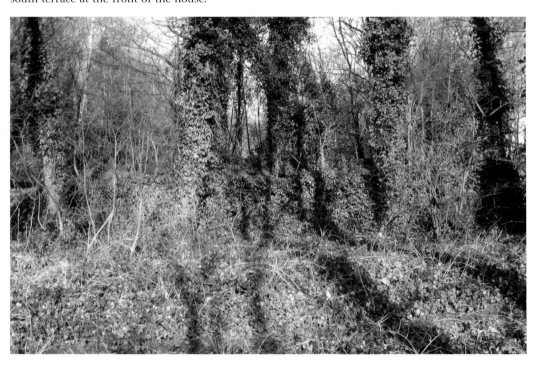

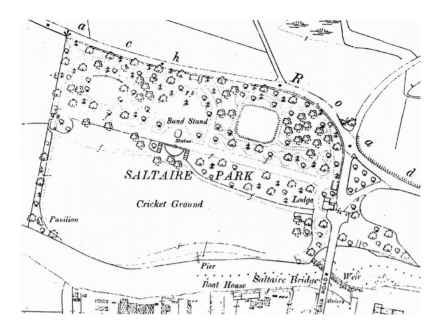

**Top Plan of Saltaire Park** c. 1870

This was the original plan of Salt's park in Saltaire. While the Institute offered a range of recreational activities, those villagers more physically inclined could find satisfaction in the public park opened in 1871. A large proportion of the 14 acres alongside the river was taken up by the cricket field but there were also facilities for tennis, archery, croquet and a bandstand. By 2009 Bradford MDC had decided upon a refurbishment costing £4.5 million of which £3.2m was received from the Heritage Lottery Fund. After five years of preparation the council's plans were realised in the spring of 2010 when a new bandstand was erected and the terrace alcoves were refurbished.

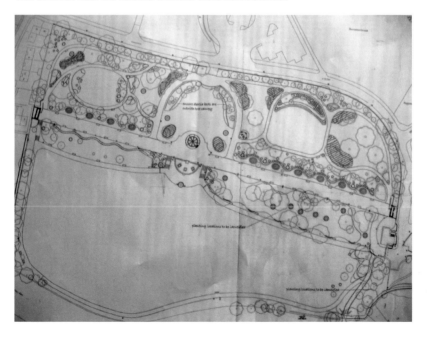

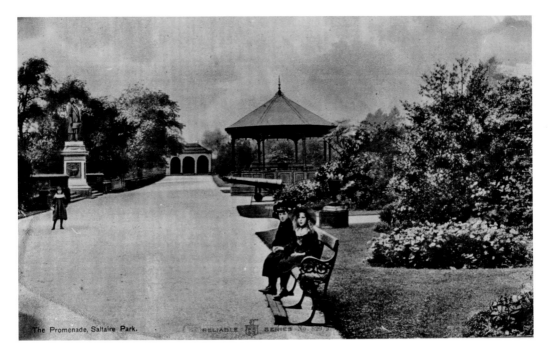

The Promenade, Saltaire Park.

## Park Promenade *c.* 1900

The parkland, on a higher level than the cricket field, had originally been laid out by William Gay who had also landscaped the grounds of Bradford's Undercliffe Cemetery, trees, shrubs and plants enveloped a number of walkways and avenues alongside a central promenade and half-moon pavilion. This promenade had originally accommodated a well used bandstand between two large cannons which had been captured at the battle of Trafalgar. The tree cover in the park is inevitably higher and foreshortens the view towards the alcoves at each end of the promenade. The design of the new bandstand below, nods distinctly in the direction of the orient.

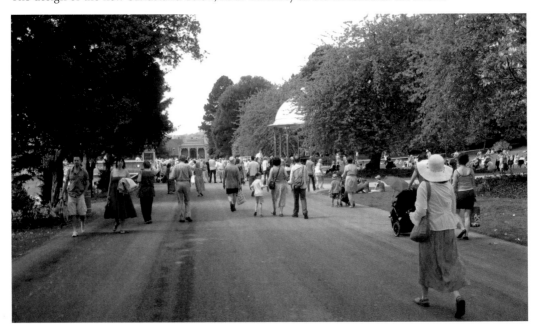

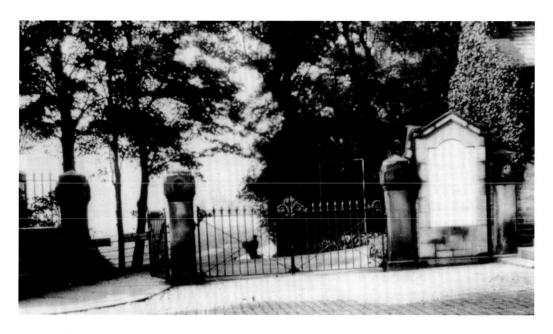

## Park Entrance c. 1930

The stone tablet to the right of the gateway confirms the gift of the park to the people of Bradford by Sir James Roberts, owner of Saltaire in 1920, as a memorial to his eldest son Bertram Foster Roberts. Beyond the wrought iron gates, was a huge board of rules and regulations for behaviour in the park. Smoking, begging, gambling and swearing were forbidden. Dogs, drunks and children under eight were prohibited. Visitors were not to interfere with the cannons or the flagpole. Enjoy yourself if you dared. The Robert's memorial remains but is now within the confines of the park lodge which is to house a new clerk of works for this magnificent new park. The red notice board (centre) has fewer rules for modern park users. The painter obviously ran out of green paint for the gates.

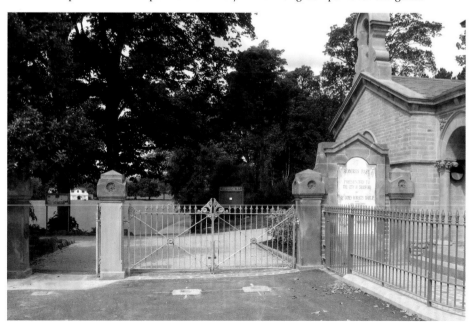

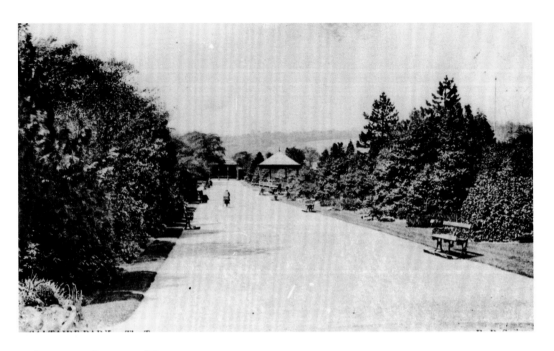

**Main Terrace (Promenade)** *c.* 1900

The planting of the gardens by William Gay in 1874 had matured well by 1900 and to the right, archery and croquet areas had been added to the 'parkscape' behind the shrubs, although the flagpole seems to have disappeared. Magnolia trees heavy with blossom now adorn the terrace looking west towards a newly furnished alcove. The ground for archery and croquet has given way to garden beds for summer planting.

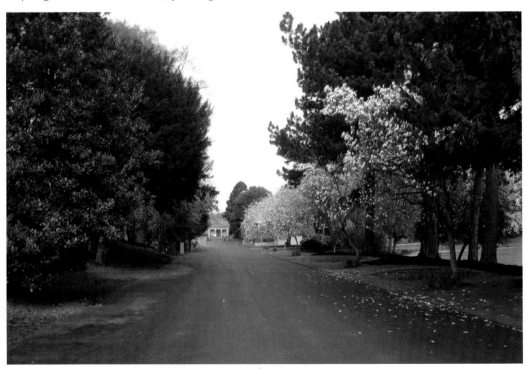

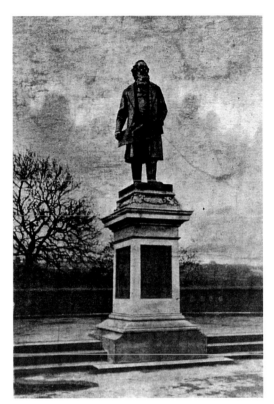

**Statue of Titus Salt 1903**
Erected in that year to commemorate
the centenary of his birth, this statue
in bronze was commissioned by James
Roberts, managing director of the mill at
that time. Standing with his back to his
palace of industry and his cherished village,
the statue of Salt is said to be holding a
scrolled plan of both. Much of what Salt
achieved can be seen from this spot.

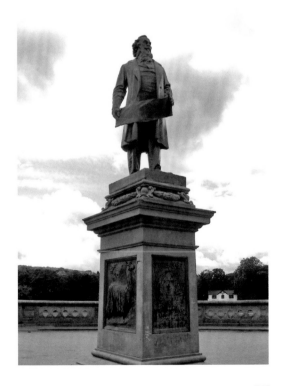

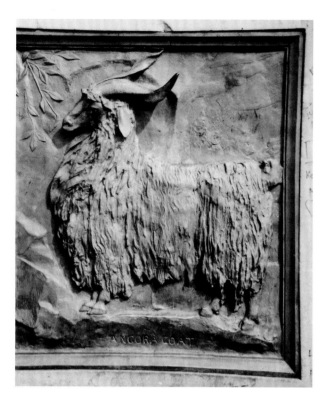

**Salt Statue *c.* 1900**
Little change or harm has come
to the statue but graffiti to the
base of the plinth has been finally
removed to expose the beautiful
bas-relief bronze replicas of the
alpaca sheep and angora goat, the
fleeces of which made Salt a very
rich man.

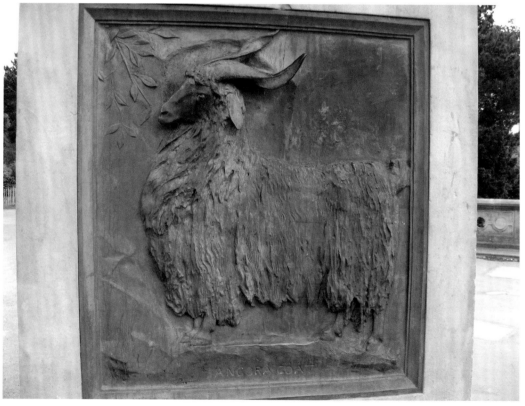

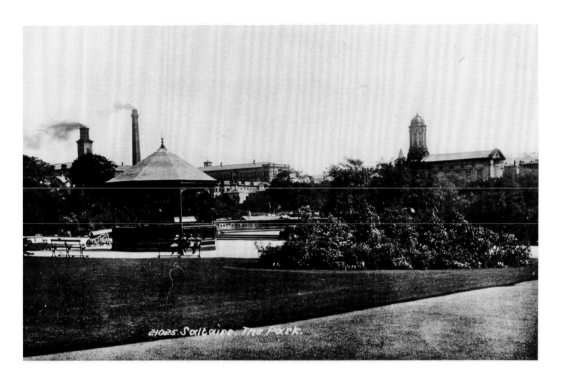

### Saltaire Bandstand

Located on the same level as the main terrace this iron bandstand hosted local bands as well as Saltaire's very own works band for weekend concerts and special occasions. To the left of the bandstand can be seen one of the two cannons from the Napoleonic era. Both cannons and the bandstand went for scrap in the war effort of the 1940s. 2010 saw the official opening of the new bandstand by Bradford MD Councillor Anne Hawkesworth. Here, she introduces the first band to "christen" the location, the Hammonds and Saltaire Band.

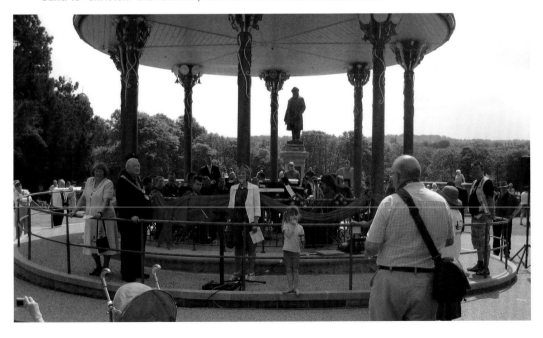

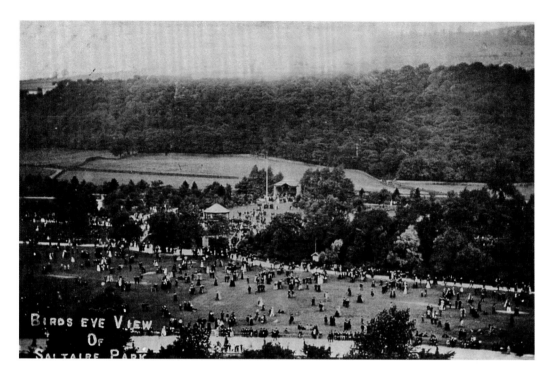

### Park Fête 1885

This splendid midsummer occasion was the highlight of the social calendar for most young people in Saltaire until well after 1914-18. Funds were raised for a variety of local charities and good causes (Salt's hospital). Not for a very long time has the old park seen such numbers of people enjoying themselves in the summer sunshine of 2010. Long may it continue.

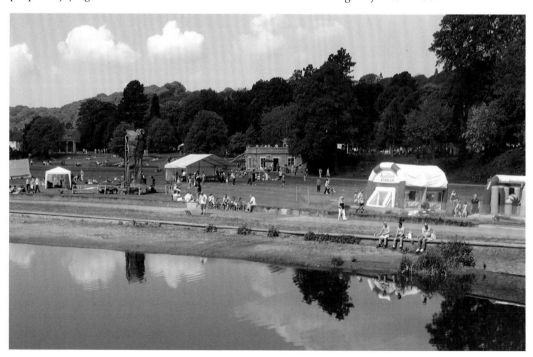

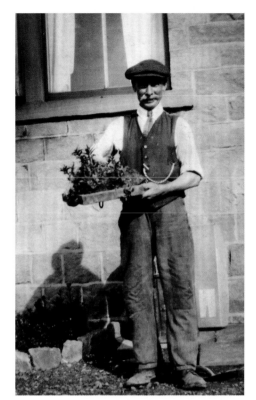

## Park Gardener

This is Charles Godfrey aged seventy-three who lived at 24 Baker Street, Saltaire and worked as a gardener at Milner Fields. He was also custodian of the clock tower there and official clock winder. Below an employee of the Bradford MDC parks department meeting all health and safety guidelines on good digging practice. Would Mr Godfrey approve I wonder? In the background the park and cricket field can be seen during a hard wet winter.

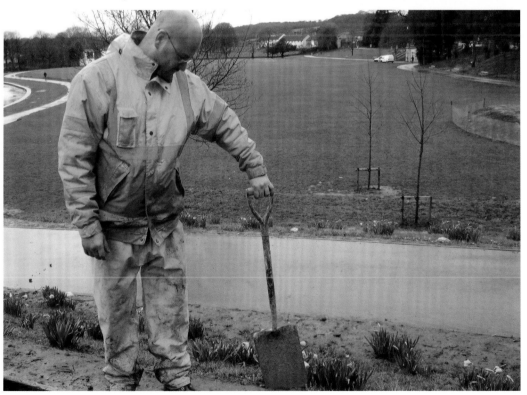

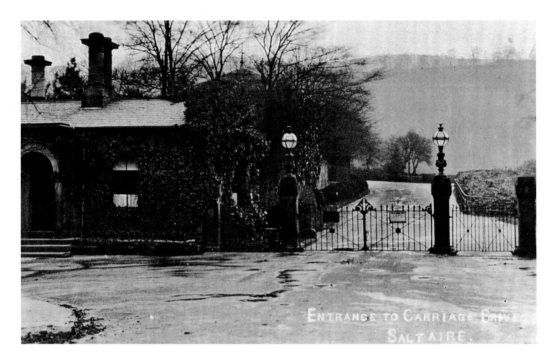

**Park Lodge *c.* 1920**

Beyond the gateway to the right was the private carriageway of Titus Salt jnr. which led to his home at Milner Field. The public had no access to this private drive at the time. To the left, out of picture is a bell tower (with bell) to signal the strict opening hours of Salt's public park. Below shows the same entrance to the carriage drive but without the middle gatepost. The road now leads to a tidy and well cared for council house estate below the Shipley Glen (less obvious in the background of this modern photograph).

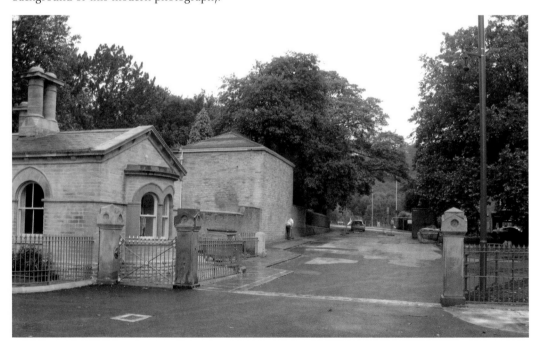

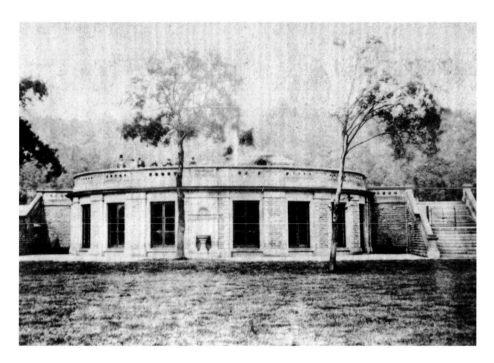

## Half Moon Pavilion 1871

At the official opening of the park 15 July 1871 local dignitaries and officials are on the balcony of this pavilion taking in a panoramic view of the mill and village as well as a sweeping vista across the cricket field. Below them and within the pavilion are facilities for refreshment. For those who could not afford to pay, a drinking water fountain is available at front centre. Like most of the buildings in Saltaire the pavilion has benefited from stone cleaning, to reveal the rich Yorkshire sandstone from local quarries. A former window of the façade has now become an entrance to a new park café in the photograph below.

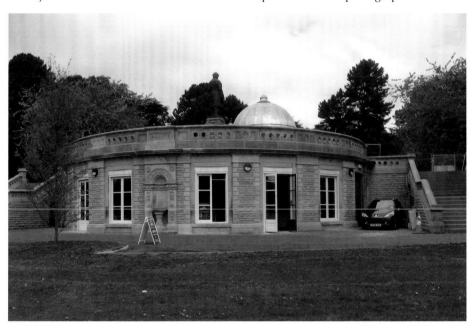

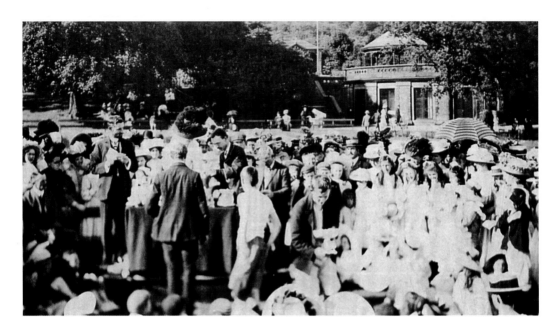

### Sports Day in the Park 1913

Before the First War the Salt's High School held its annual sports day in the park. Here young athletes are presented with their prizes. The half-moon pavilion and bandstand make an imposing backdrop to this summer scene before the coming of war in France cast its long shadow across the lives of these young people. As spectators on the belvedere watch a display of Morris dancing on the promenade, below them families and young people soak up the sunshine at the Fun Day, 2010.

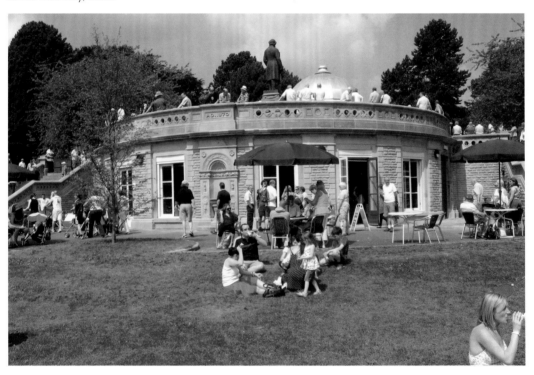

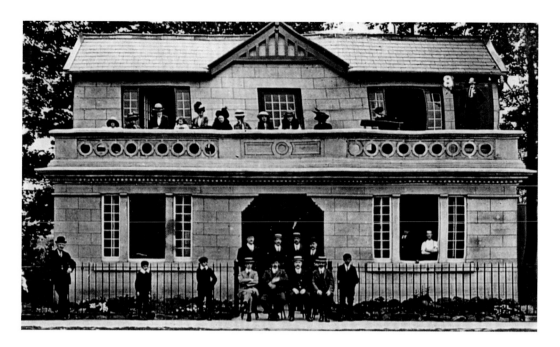

Cricket Pavilion *c.* 1918

Members of the cricket club committee pose before the entrance to this newly built pavilion and scoreboard just after the First War. Perhaps Saltaire's greatest ever cricketer features here. Sydney Barnes was renowned internationally as a pace bowler before he began his professional contract with Saltaire in 1915 aged forty-one. During the next eight years he took 100 wickets in a season for the club on five occasions (150 wickets in 1920) and never more than at eight runs each. His batting career at Saltaire invariably averaged twenty runs per knock. In Bradford League terms, a cricketing legend walked these rooms at that time. The Cricket Pavilion in 2010, after its spring clean and a lick of paint.

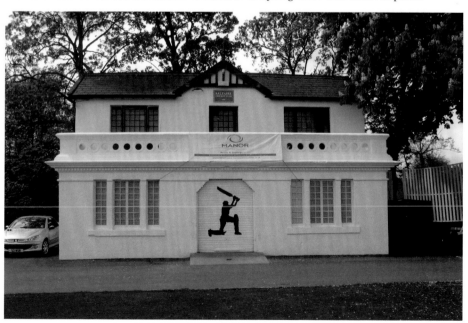

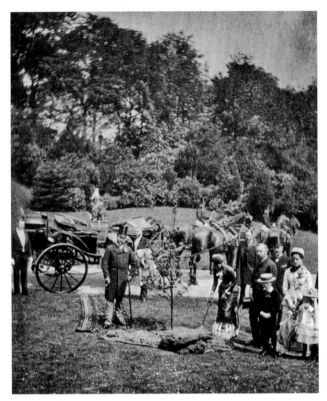

**Tree Planting in the Park
June 1882**
The Prince of Wales (left) accompanied by Princess Alexandra plants a tree in Saltaire Park in memory of its founder. To the right are Titus Salt jnr. his wife Catherine and two of their children, Gordon and Isabel. Tree planting 2010 and of a much less formal/ official nature, courtesy of the staff of Bradford park's department.

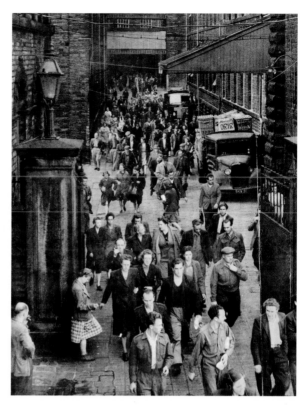

**Mill Gate c. 1955**

As the buzzer blows and the shift ends, workers in there hundreds pour out from the mill yard. Such a sight will never be seen again. The end of the First World War 11 November 1918 was signalled by a loud blast on the new buzzer at the mill. The noise was sufficiently loud to silence a band concert three miles away in Lister Park, Bradford. A couple of catering delivery vans are parked in the yard but not a mill worker can be seen here in the post industrial age. To the right is the original security office and clocking-in centre.

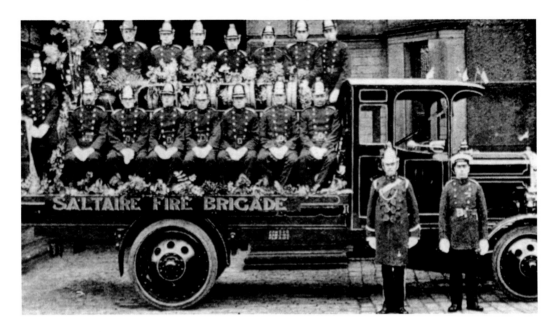

## Mill Fire Brigade c. 1935

Here volunteer employees from the mill assemble at the entrance to the mill yard. At that time the Chief Fire Officer was George Hall (standing front). The firemen also undertook valuable fire watching duties during the war. Today the fire station is located in Saltaire Road opposite Exhibition Road but has no working connection with the mill. Here members of the West Yorkshire Fire Service stand proudly before one of their up to date appliances.

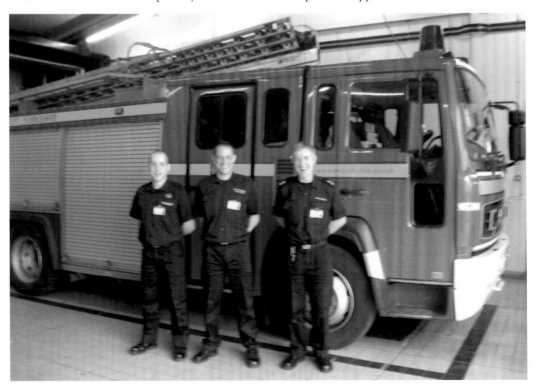

### Saltaire Nursery

Your authors are not entirely certain where these were located in Salt's day and would welcome any information from readers. They clearly existed and probably were close to the park. Following a successful horticultural course at Shipley College, a group of staff and students helped to set up this popular plant outlet some years ago. It later moved into private ownership.

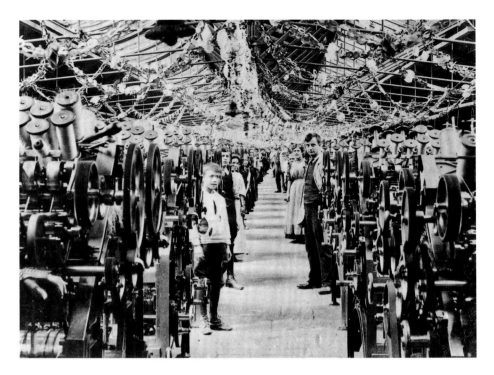

## West Mill

The spinning department at Salt's mill in 1902. The decorations in this part of the mill (West Mill) mark the delayed coronation of King Edward VII. Although Victoria had died in January 1901 her son's succession was postponed until the summer of 1902 owing to Edward's sudden illness from peritonitis. West Mill 2009. Today, this part of the mill is given over to book sales, David Hockney prints and the excellent Salt's Diner, the idea of the mill's late owner, Jonathan Silver.

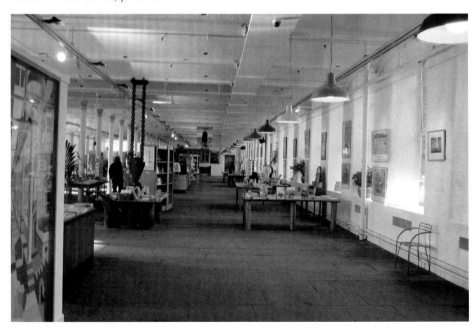

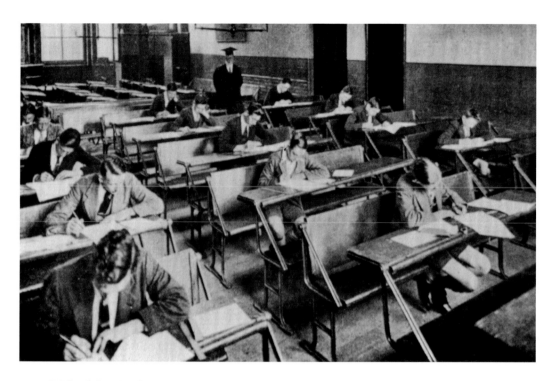

## Salt's High School 1925

The school offered a few privileged boys (!) the chance to climb an educational ladder to university. Here a handful of boys are sitting the school certificate examination to begin that climb. Today, students of the college follow a less academic route to the top by taking advantage of the vocational courses on offer at the college e.g horticulture, building and construction. Here students are trained outside the college building in the use of a theodolite.

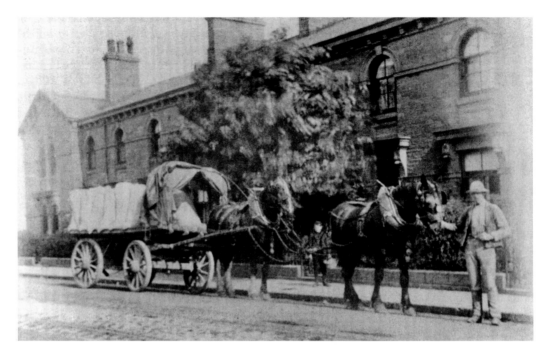

**Flour Dealer** *c.* 1900

At the turn of the twentieth century when most people made their own bread, a flour dealer here delivers his wares to private houses in Gordon Terrace. Or maybe this was one of the small private business ventures which converted these houses into shops prior to 1914? Bread being delivered 2010. Shop-bought bread in Saltaire has become more sophisticated as the twenty-first century begins.

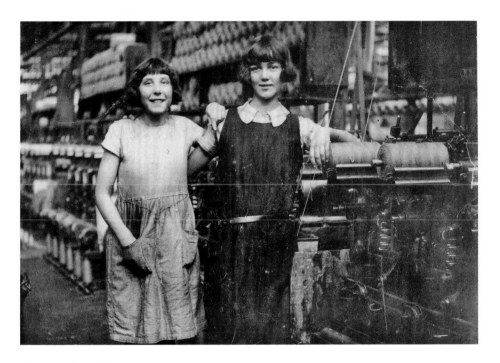

## Mill and Shop Girls c. 1930

At this time for many children, and girls in particular, staying on at school was not an option. Here, fourteen-year-old Lilian Marsden and her friend Phylis pose proudly for the camera in Saltaire's spinning department between the wars. The closure of the mill in 1986 severely reduced employment opportunities for girls and young women. Here, two are busy in Salt's village bakery and tearoom in Victoria Road.

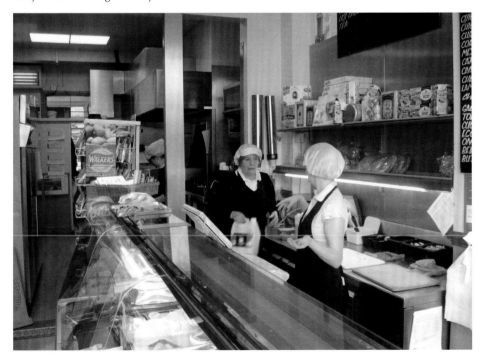

## Home Deliveries c. 1900

Before the development of modern consumerism, street hawkers like Willie Cox were the mainstay of much working class shopping. Cox lived nearby Saltaire and made a simple living selling firewood around the village. Other street hawkers of the inter-war years included Maurice Milton (milk), Billy Goodson (greengrocer), Jack Nichols (coalman), Mrs Hyden (knocker-up) and Mr Tweedy (lamplighter). Deli-Fresh 2010. Here, delicatessen goods are delivered around modern Saltaire.

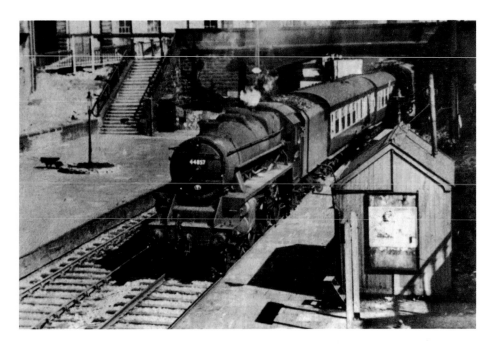

**Railway Work**

An unnamed Stanier Class 5 steams past Saltaire Mill and into the station which had offered a handful of employment opportunities before the station was closed in 1965. Denationalisation and the privatisation of regional contracting have reduced further the number of jobs available on the modern railway. Here a regular diesel service between Skipton and Leeds still caters for the railway needs of Aire Valley commuters albeit seats are at a premium at certain times of the day.

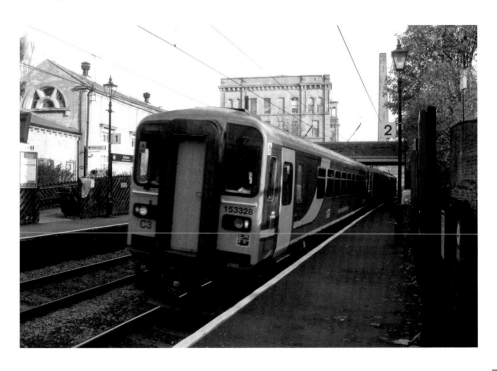

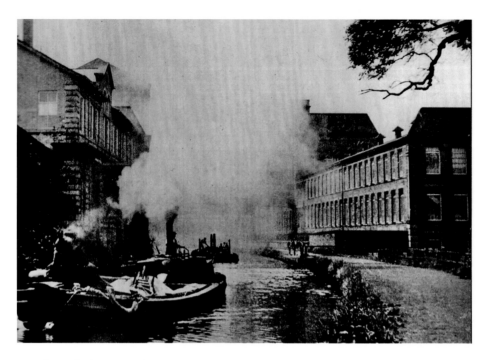

Canal at Saltaire *c.* 1936

The Leeds-Liverpool Canal Company employed several maintenance boats at the Shipley basin following nationalisation of the waterways after 1948 and these (Leeds bound) are in operation here between New Mill and the main mill. A private canal barge selling hot drinks, moors beneath Victoria Road bridge on the new mill side of the Leeds-Liverpool canal at Saltaire. There is little commercial traffic on the canal these days.

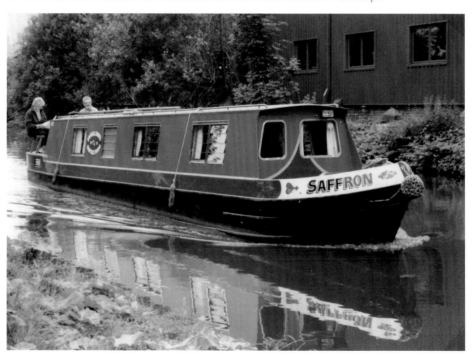

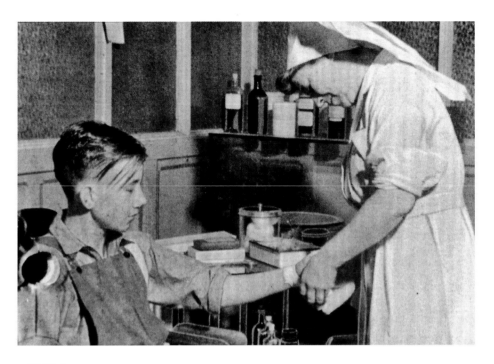

Mill Clinic c. 1950

This clinic was run by a fully trained nursing sister (here Mrs James) and a male assistant. There were twice weekly visits by a doctor and dental treatment was available for all insured employees. Saltaire residents today have access to a fully modernised and well equipped surgery as part of the Bradford NHS Trust.

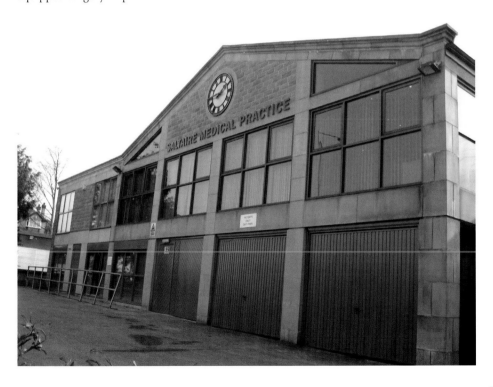

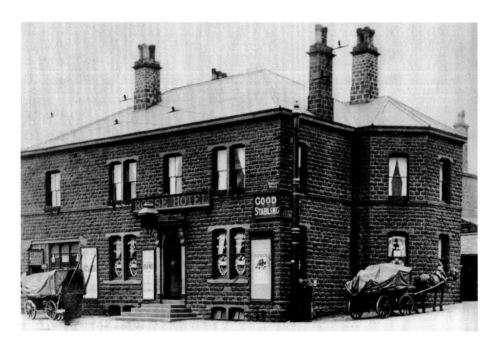

### Innkeeping at The Rosse Hotel c. 1905

Titus Salt is often labelled as teetotal and anti-alcohol following his moral survey of Bradford in 1848/9. Yet, at his home he served wine and he agreed to an off licence in the village as early as 1867. During his lifetime and beyond, no public house was ever built in Saltaire but this house was granted a licence in October 1870 and is as close as possible to the community without being part of it (junction of Saltaire Road & the Keighley Road). Below you can see the Saltaire bar 'Don't Tell Titus'. Officially there is still no public house in the village although one or two of the bar and brasserie establishments now have liquor licenses. This one in Victoria Road gets the prize for cheek.

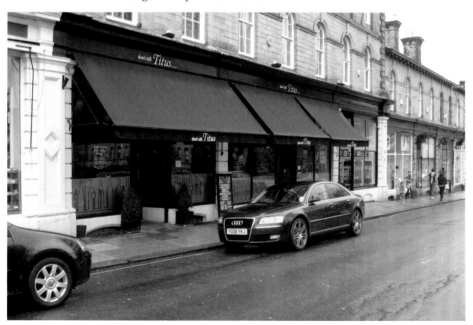

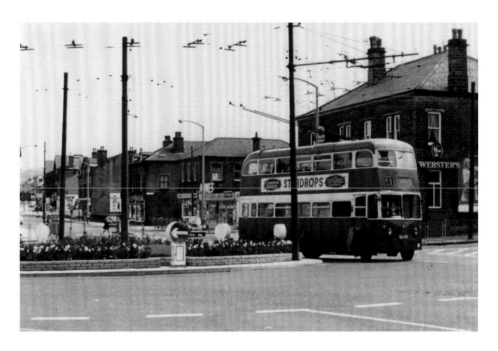

**Saltaire Roundabout (Rosse Hotel)** *c.* 1970

Here, a Bradford Corporation trolleybus takes the busy Saltaire roundabout outside the Rosse hotel. A trolleybus service between Saltaire and Bradford had operated between 1939 and 1978. This vehicle however has probably completed the service from Thackley to Saltaire and is on its way to Bradford (City line). Saltaire roundabout 2010; a 'First' bus approaches the roundabout via Moorhead Lane on its way to West Baildon.

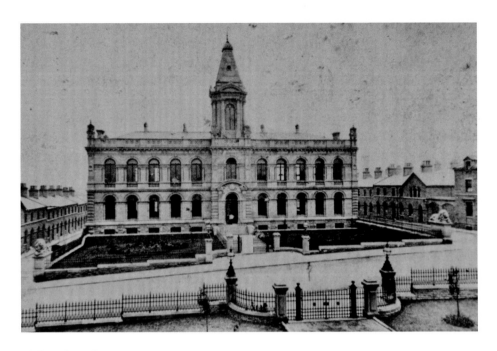

## Club and Institute *c.* 1890

This building was Salt's answer to alcohol and the evils of drink. In its day it offered his working men a wide range of rational recreational opportunities. Membership was cheap and the hall provided a home for numerous clubs and societies. Today it still hosts concerts and balls and the concert hall is available for public hire. To the right of the main entrance is the Museum of Victorian Reed Organs and Harmoniums (open Sun-Thurs 11.00-16.00).

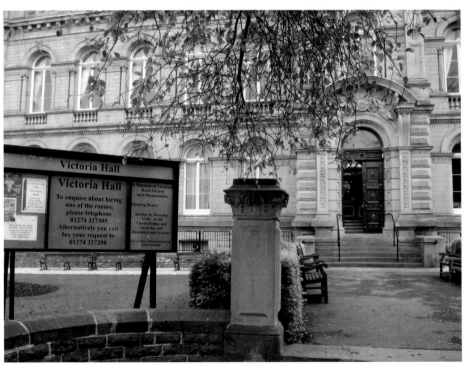

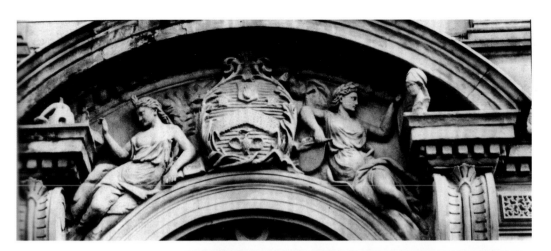

**Entrance arch to Club and Institute 1868** Thomas Milne's sculpted entrance arch has two female classical figures thought to represent Art (palette and brush, right) and Science (with retort and scales). 'Bacchus' 2010. Milnes's sculptures also feature above the façade windows of the Victoria Hall and curiously include the head of Bacchus, the Greek God of wine.

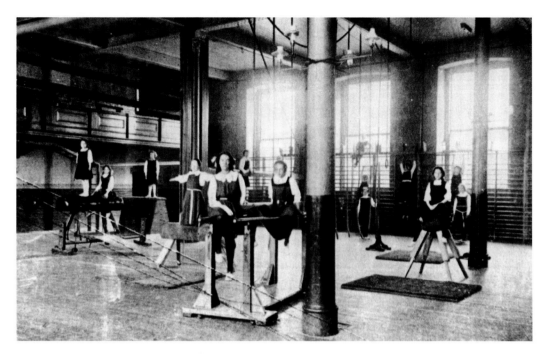

## Gymnasium 1915

These girls from the Salt's High School are making use of the fully equipped gymnasium installed by Salt inside the Institute in 1870. The club was later to be successful in national competitions and included several individuals like E. Pickles who represented their country. The gymnastic club closed shortly after the second World War but here in 2010 a young man springs into action on the recently opened children's playground and skateboard area.

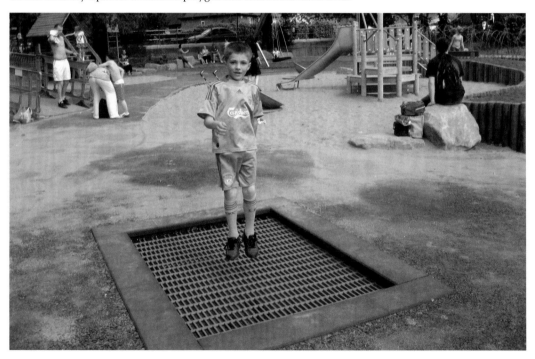

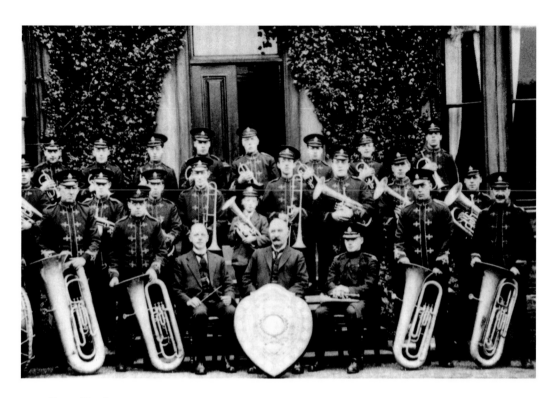

**Brass Band *c.* 1900**

The brass band movement had its origins in the Sunday School and Temperance movements but after 1850 northern millowners like Salt and Foster of Black Dyke mill also financed works bands. Here, the Salt's mill band sport their success in the national competition of 1900. Below, the Yorkshire Wind Orchestra who played at Victoria Hall, Saltaire in 2009.

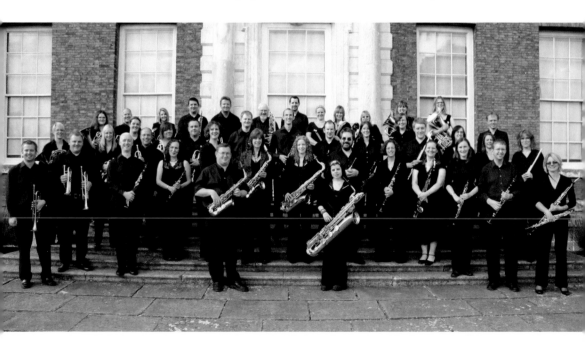

**Hirst Farm c. 1939**

A location fond in the memories of many Saltaire residents who liked to stroll through Hirst Woods or along the canal bank before 1960. In the years on either side of the Second World War, this eighteenth century farmhouse with its stepped chimney stack and white-washed walls became a popular refreshment point for ramblers and weekend walker. Farmer Whincup, pictured here on the extreme left, was the first owner to offer jugs of tea and home baked scones during the 1930s. Later, George Bagshaw was more famed for his home made dairy ice cream, and his bamboo fishing nets for catching "tiddlers" in the canal. Below is the Hirst Farm site in 2010. This late Edwardian playground has become a municipal car park for towpath and woodland visitors.

**Works Trip** *c. 1900*

The tradition of the annual works outing introduced by Titus Salt was continued long after his death and well into the next century. Here mill girls in their Sunday best enjoy a day out at Bolton Abbey. This road sign in Saltaire Road shows a reversal of the tourist trend whereby thousands now visit the workplace of the girls in the photograph above.

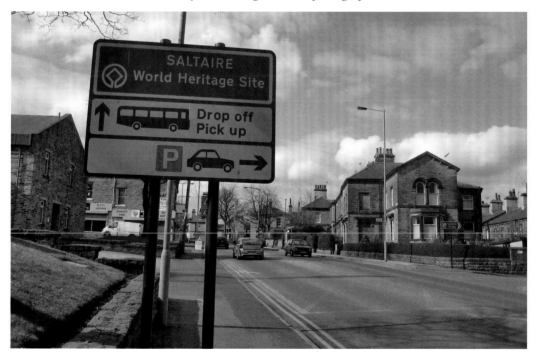

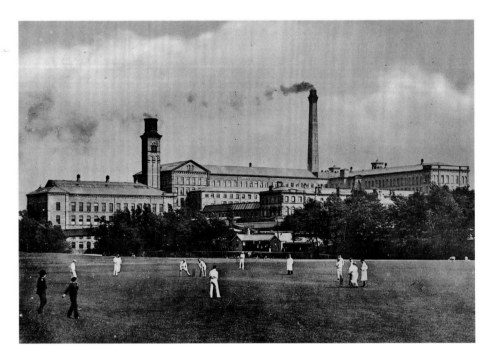

**Saltaire Cricket Club 1916**

From the very outset the cricket field at Saltaire was always the home of the Saltaire club, founded in 1869 when it had 146 members and was a founder member of the Bradford Cricket League. Several cricketing legends have close ties to the club including Sid Barnes, R. G. Barlow and Jim Laker who was given his Bradford League baptism aged fifteen at Baildon Green in 1938. Still competing in the First Division of the Bradford Cricket League, the Roberts Park home of the club has recently undergone a makeover, as shown below in 2010.

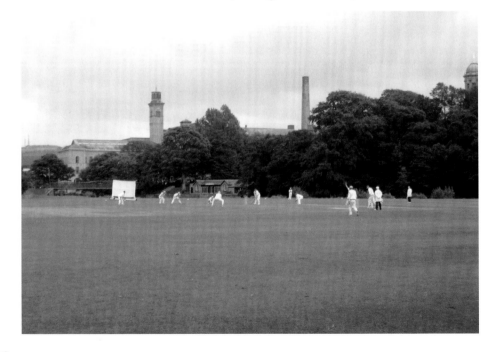

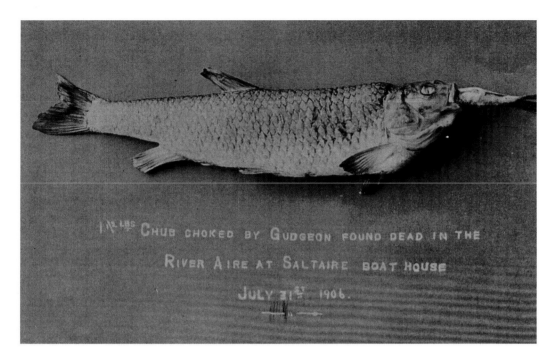

CHUB CHOKED BY GUDGEON FOUND DEAD IN THE
RIVER AIRE AT SALTAIRE BOAT HOUSE
JULY 31ST 1906.

## Saltaire Angling 1906

Founded in the 1860s, this club held regular competitions along the river Aire during the trout season (after 1 March). Here, close to the boathouse a member netted a chub choking on a gudgeon in July 1906. Angling continues to be one of the nation's most popular pastimes. At Saltaire the angler has a choice of river or canal. Here a lone fisherman relaxes on the riverbank close to Hirst Wood, 2010.

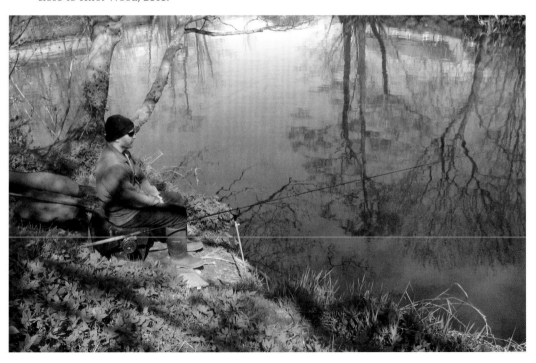

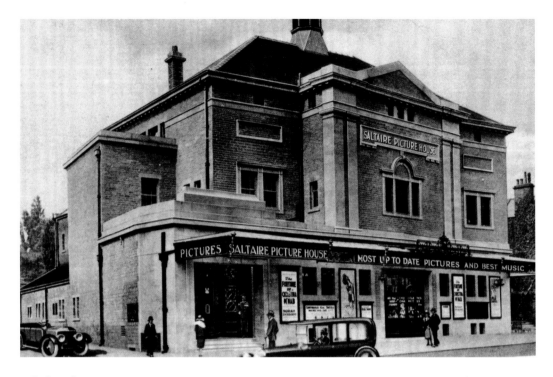

**Saltaire Cinema**

The 'picture house' symbolised the growth of mass leisure industries after 1918. Built in 1922 on the boundary of Saltaire village, this cinema could seat an audience of 1,500. It was later renamed the Gaumont but was closed in 1957. The cinema was demolished to make way for this garage and petrol station, in the second image.

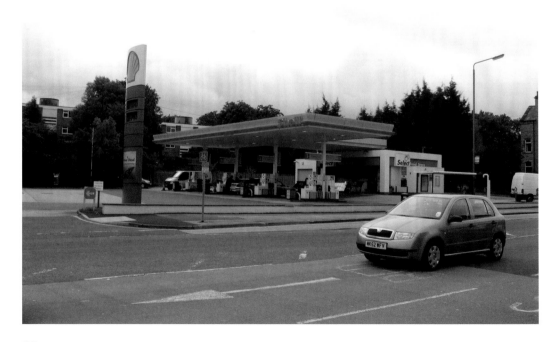

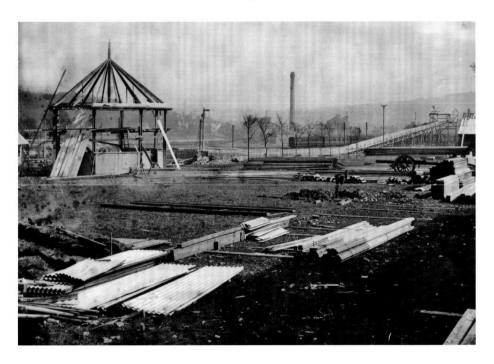

## Saltaire Exhibition 1887

Also known as the Royal Yorkshire Jubilee Exhibition. This exhibition was hosted by Saltaire on this site close to the mill towards Shipley. There were several delays to the opening owing to the bad weather but here the bandstand café and photographic studio are under construction. In the distance, can be seen the Maze and Toboggan Run which ran parallel to the railway line between Leeds and Skipton. Today the site is largely occupied by allotments and the premises of the Shipley College, as well as housing in Maddocks, Rhodes and Baker Streets which may have been an extension to Saltaire's housing stock in the 1890s.

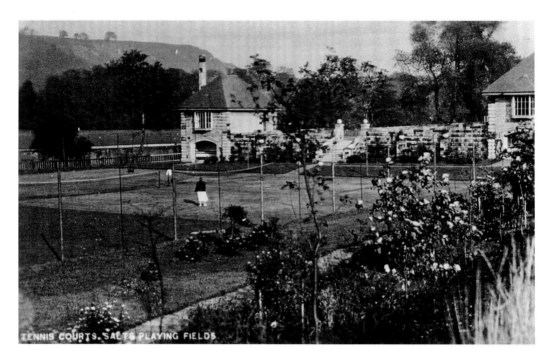

TENNIS COURTS. SALTS PLAYING FIELDS

### Salt's Playing Fields 1935

In 1923 the mill company had reorganised as Salt's (Saltaire) Ltd and rode out the economic difficulties of the inter-war years. As a result, the company bought back from the Shipley council, 31 acres of land which were converted to much needed public recreation grounds for tennis, bowling, cricket and soccer. These tennis courts were provided by the mill company in 1925 as was the social clubhouse which was originally located between these two pavilions.

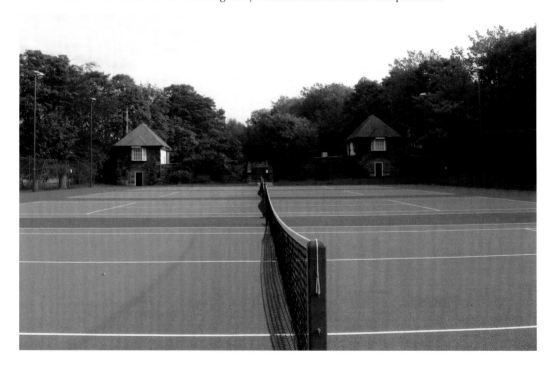

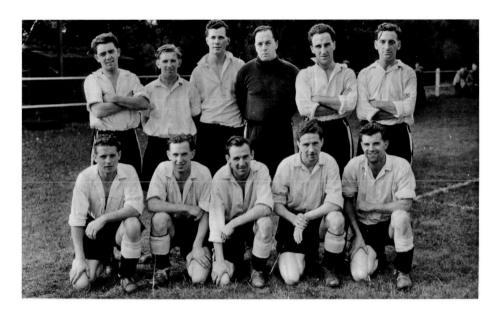

**Salt's AFC Soccer 1953**

This club had its golden years in the 1950s but its origins lie in a work's team from the Saltaire mill which had played at Hirst Wood since 1914. The club made good progress in the Bradford Amateur League and this team, by 1953, had won the West Riding Challenge Cup, Bradford & District Cup and had even played in the FA Amateur Cup.

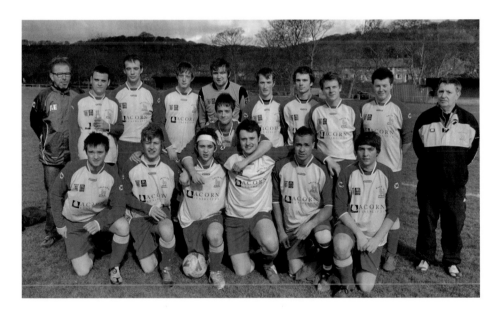

**Salt's AFC 2010**

Playing on the same ground the junior section of the club are about to take on Shipley Town juniors in a keen fought local 'derby'. The senior team now play in the West Riding County Amateur League. General Manager of the club Paul Whitehead tells me that they have 500 registered players 'aged seven to death' who play in thirty-eight different teams. Here the juniors are managed by Robert Barker and Andy Eastell (back row).

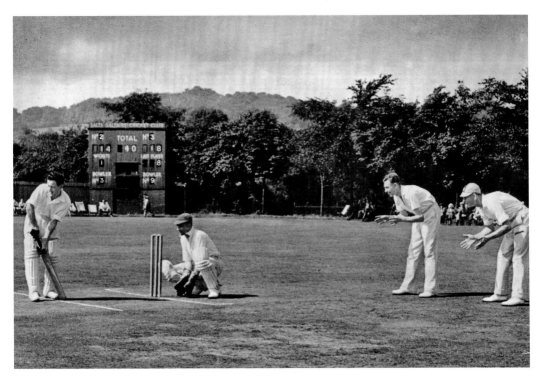

**Salts (Saltaire) Cricket Club** *c.* 1955
Confusingly, Salts and the original Saltaire Club were members of the Bradford Cricket League until the former was disbanded in the late twentieth century. Today the cricket club's picturesque riverside ground is home to Shipley Provident Cricket Club who here take part in a match against Yeadon.

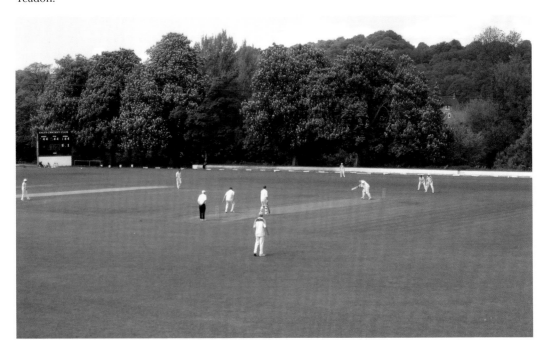

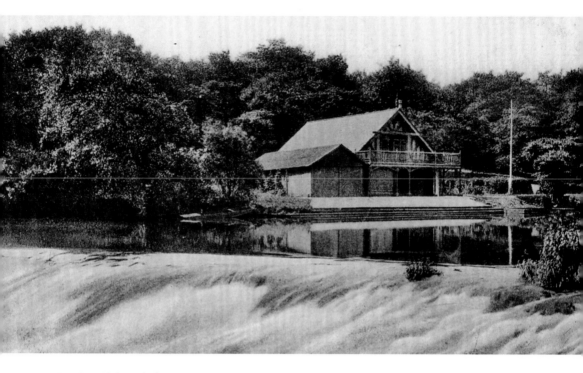

## Rowing Club, Saltaire *c.* 1920

The Bradford Amateur Rowing Club has used this stretch of the River Aire since the 1890s and had built this boathouse upstream from the weir at Hirst Mill. In 1920 the mill's new tenant, Mr Glyn Thomas objected to the antics and noise of club members and consequently in 1922 the boathouse was taken down and rebuilt as here in 2010 on the opposite bank of the river.

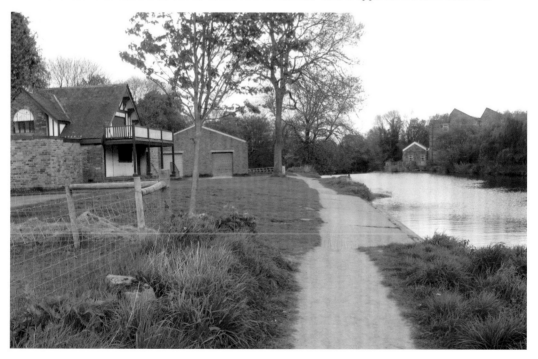

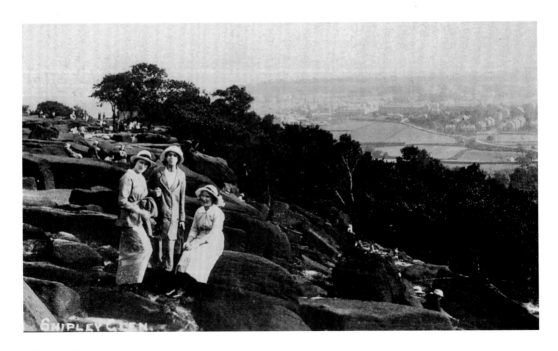

### Shipley Glen c. 1910

These irregular shaped boulders on Shipley Glen, close to Saltaire, were the creation of the Ice Age, when sandstone debris was dumped by the glacier as it retreated in the warmer climate. It was a local Baptist minister who first drew public attention to the site at Brackenhall Green in the 1840s when he brought his Sunday School scholars here for their annual Whitsuntide excursion, so beginning the Glen's reputation with Shipley and Bradford pleasure seekers. The site continues to be a place of natural beauty, and a favourite with local residents. In the distance can be seen the sprawling suburbs of Shipley as they have overrun Saltaire westwards.

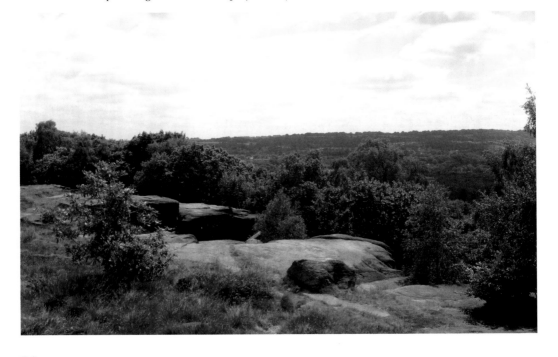